IMAGES
of America

FILIPINOS IN CARSON AND THE SOUTH BAY

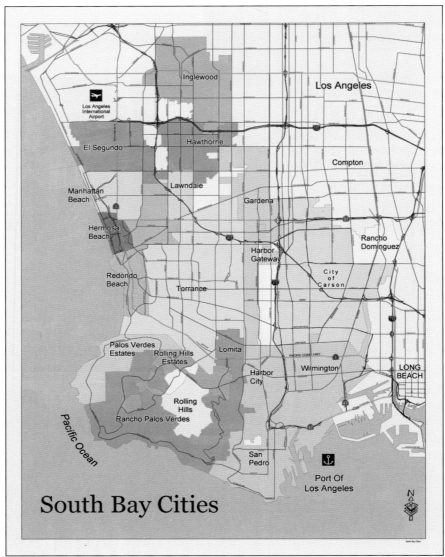

South Bay Cities

This is a contemporary map of Carson and surrounding Los Angeles South Bay area. Although Carson was not incorporated into a city until February 20, 1968, the area had long before been home to many Filipinos since the early 20th century. They knew the region as the Los Angeles Harbor Area and so named their first Filipino organization the Filipino Community of LA Harbor Area, Inc. Carson is also the home to Cal State University Dominguez Hills, Home Depot Sports Center, and the popular Goodyear Blimp. The city also shares history as part of the 1984 Olympics with its Cycling Velodrome venue. (Courtesy of City of Carson Public Information Office.)

ON THE COVER: A group picture of the First Philippines Independence Day Banquet for the newly formed Filipino Community of Los Angeles Harbor Area at the Hilton Hotel in Long Beach was taken July 4, 1946. A year later, they celebrated their second Fourth of July on the grounds of their Filipino Community Center at 323 Mar Vista Avenue, Wilmington, California. (Courtesy of Kenny Dionzon.)

IMAGES
of America

FILIPINOS IN CARSON AND THE SOUTH BAY

Florante Peter Ibanez
and Roselyn Estepa Ibanez

ARCADIA
PUBLISHING

Published by Arcadia Publishing
Charleston SC, Chicago IL, Portsmouth NH, San Francisco CA

Printed in the United States of America

Library of Congress Control Number: 2009920003

For all general information contact Arcadia Publishing at:
Telephone 843-853-2070
Fax 843-853-0044
E-mail sales@arcadiapublishing.com
For customer service and orders:
Toll-Free 1-888-313-2665

Visit us on the Internet at www.arcadiapublishing.com

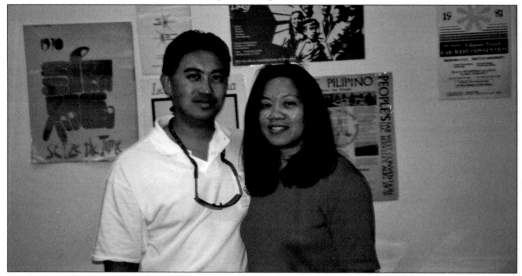

Coauthors Florante Peter Ibanez and Roselyn Estepa Ibanez were community activists even before they met at the 1973 Filipino People's Far West Convention (FWC) in San Jose and were married a year later, a week after participating with the 1974 FWC at UCLA. Both came from navy families, Roselyn from National City in San Diego, California, and Florante from Wilmington, California. They were both activists in the Union of Democratic Filipinos (KDP) organizing against the Marcos dictatorship in the Philippines and for social justice in America. Roselyn has a master's degree in public policy and administration, works for the City of Los Angeles in the Department for Neighborhood Empowerment, and currently is the board chair for the Filipino American Library. Florante earned his master's degree in Asian American studies and a master's degree in library and information science from UCLA. He works for Loyola Law School as their manager of Library Computer Services and is also an adjunct professor at Loyola Marymount University in Asian Pacific American studies. They have raised two daughters, Gabriela Ibanez Nguyenphuoc and Mikaela Estepa Ibanez. This photograph was taken in 1995 during their presentation on the Filipino American Movement of the 1970s.

CONTENTS

Acknowledgments 6

Foreword 7

Introduction 8

1. Coming to America to Labor and Serve: 1910s–1930s 9

2. Growing Up as American-Filipinos: 1940s–1950s 25

3. Raising Families and Getting Involved: 1960s–1980s 51

4. Local Legends: Bobby Balcena, Auntie Helen Brown, and Uncle Roy Morales 73

5. Arts and Culture: From the Rocky Fellers to Festivals and Hip-Hop 85

6. An Empowered Community Emerges 101

7. *Sulong* Means Moving Forward 111

ACKNOWLEDGMENTS

The authors are deeply appreciative to both the Filipino American Library (FAL) and Association for the Advancement of Filipino American Arts and Culture (FilAm ARTS), both nonprofit community organizations, for their generous help and support for this book project. Thanks also to the Filipino American National Historical Society (FANHS), Visual Communications, Search to Involve Pilipino Americans (SIPA), UCLA Asian American Studies Center, Kababayan at UC Irvine, Cal State University Long Beach Pilipino American Coalition (PAC), and UCLA Samahang Pilipino. Very special thanks go to the Rossi, Estepa, Ines, Morales, Brown, Apostol, Cariaso, Hatch, Chrisman, Guerrero, Lamug, and Legaspi families. Individuals Phil Ventura, Bob San Jose, Eloisa Gomez Borah, Jun Aglipay, Joe Palicte, Mike Dagampat, Marie SaHagun-Taitague, Carson mayor Jim Dear, Maj. Valvincent Reyes, and Luis Sinco also contributed to the making of this book. For their encouragement and advice, our thanks go out to the City of Carson—Public Information Office; Cal State University at Dominguez Hills Archives; the Wilmington, San Pedro Bay, Torrance, and Long Beach Historical Societies; as well as LA as Subject. We are indebted to fellow Arcadia authors Mae Respecio, Carina Montoya, Dawn Mabalon, Dorothy Cordova, and Hank and Jane Osterhoudt for photograph leads and advice. Lastly we would like to honor and thank Clarice "Tawa" Montayre Desuacido for her treasure of historical photographs and stories. In many ways, she helped "connect the dots" between families and references. Special thanks to the precious family album contributions from our mother, Laura Ines Rossi; uncle Marcelino Ines Jr.; and auntie Ana Ines Cariaso. Please forgive any credit omissions done unintentionally. We thank all who have helped in any way with the production of our book. Our final thanks are to God who makes all things possible. (Any photographs lacking a courtesy note were supplied by the authors.)

FOREWORD

As a researcher on the history of Filipinos in America for over 30 years, I am painfully aware of how little is generally known about this history. This is despite the fact that Filipinos are the largest Asian group in California, according to the 2000 U.S. Census. In fact, Filipinos are also the earliest arrivals to America from Asia, landing in the New World as seamen on Spanish sailing ships during the Manila Galleon Trade in the 16th century.

Only in recent years has some focus come to communities where Filipinos live or have lived. In Los Angeles County, more are learning about the Filipinos who settled near downtown Los Angeles—originally in the Little Manila area near Main and First Streets—who were pushed by developers to Bunker Hill before relocating in the Temple/Union area designated by a City of Los Angeles proclamation in 2002 as Historic Filipinotown.

Florante and Rose Ibanez know their community of Carson well and are uniquely qualified to shed light on the Filipino communities in Carson and the surrounding areas of the South Bay and to introduce the little-known early history of Filipinos in these areas of Los Angeles County.

This is the first book to focus on this geographically significant area. The Port of Los Angeles was a common entry point in the early 1900s for Filipinos traveling from Seattle, San Francisco, and other cities to find jobs in Southern California. Many of these Filipinos found employment in the Los Angeles Port area, in canneries and fishing businesses in San Pedro and Terminal Island, and in farms then located in Torrance and Palos Verdes.

This book provides an opportunity to learn a new dimension about Filipinos who lived, worked, and played in South Bay communities such as Wilmington, San Pedro, Long Beach, and Torrance. The earliest Filipinos who settled in the South Bay communities were among the Filipino population of predominantly single males arriving as early as 1910. However, despite laws against mixing races, they had gone to marry in Mexico or in states without such anti-miscegenation laws. They had families, and their children attended local schools in the South Bay and played on sports teams in their communities and beyond. Unlike Filipinos in central city rental housing, they found communities where they could buy homes, despite the prevailing racially restrictive covenants and other discriminatory housing practices.

See these earliest arrivals joined by Filipinos in the U.S. Navy base in Long Beach, World War II war brides from the Philippines, and post-1965 professionals. Journey through the photographs in this book and bear witness to the rich history of these Filipino communities.

—*Eloisa Gomez Borah*
Life Member, Filipino American National Historical Society

INTRODUCTION

Many Filipinos can attest that they know at least one relative or friend living in Carson, California. Today Carson is widely recognized as one of the largest Filipino American enclaves in the United States. Although Carson only became an incorporated city in 1968, the story of Filipinos arriving and raising families in the Los Angeles South Bay/Harbor area began much earlier. It is widely recognized that there were roughly three major waves of immigration to the United States. The first was made up of the earliest immigrants from the early 20th century to World War II. The related military/war brides wave followed, and lastly the third wave began following changes from the U.S. Immigration and Nationality Act of 1965. They came for many individual reasons, but to understand them, you must first examine the unique historical relationship between the United States and the Philippines, both as a conquered colony and stepping stone to Asia, as well as the "Pearl of the Orient" and staunch democratic American ally.

As college students in the 1970s, we became suddenly aware of our identity as Filipinos in America. Along with other communities of color, we wanted to know what "our" history was. We had no Filipino American heroes nor did we know much about the Philippines. We became passionate to discover our "roots." At the same time, a nationalist movement was occurring in the Philippines to correct the national history that had been taught from American colonial textbooks. Names like Jose Rizal, Andres Bonifacio, Gabriela Silang, and Emilo Alguinaldo came forward from Philippine history, but no names surfaced from the Filipino American experience. As students, academics, and community organizers came together during the annual Filipino People's Far West Conventions (FWC) of the 1970s and 1980s, we learned from each other not only how to organize but to also recognize and share our own rich history. One of the results was *Letters in Exile: An Introductory Reader on the History of Pilipinos in America*, which was perhaps the first Filipino American studies textbook put together by students at UCLA in 1976 who had their first Filipino American studies class taught by Casmiro Tolentino.

Our purpose in creating this book was to share and preserve the photographs, the history, and stories of Filipino Americans from our hometown. Each photograph has a story behind it, a family, an organization, or an individual, and each has made a contribution to the building of America. We believe that we are all heroes in some way, as role models, spokespersons, and even as the family breadwinners. The call for photographs and stories resulted in many more than could be included in this book. It is our goal to include more in an archival Web site to be sponsored by the Filipino American Library. We commend Arcadia Publishing for producing books that reflect local histories and contribute to diversity of our collective memory. We hope you find our book enjoyable as well as educational and share it with your family and friends as a way to spark discussions of your own stories.

One

COMING TO AMERICA
TO LABOR AND SERVE
1910s–1930s

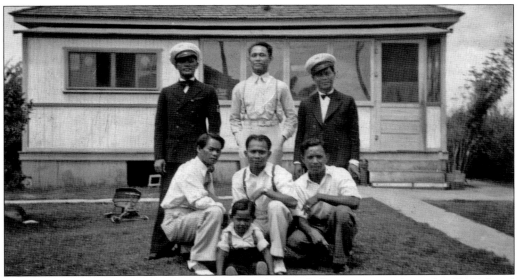

The early Filipino pioneers came into Los Angeles South Bay area as early as the 1910s, lured by the promise of making it rich and with intentions of sending money back to their families in the Philippines. Of the many provinces providing their young men to work in America, a large portion came from the Ilocos regions in northern Luzon. Later this entire generation of vibrant, eager, and hardworking men would collectively be called *Manongs*, a title of respect for an Ilocano elder. The few Filipino women who came in this period as wives and their daughters were considered the "orchids" of this largely bachelor society. Others arrived by joining the ranks of the U.S. military, many recruited at Sangley Point, Philippines, for the U.S. Navy. Here Al Bitonio (the child) poses in front of his family home in San Pedro with his "uncles." (Courtesy of Al Bitonio Collection.)

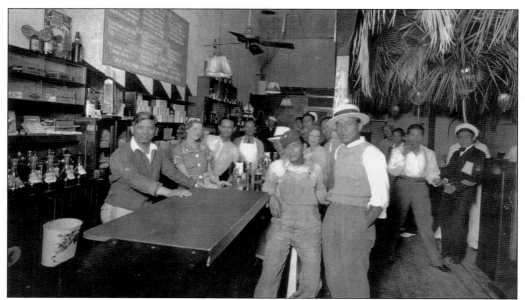

Filipinos gathered in hotels, cafés, and barbershops in San Pedro, most of them near the corner of Beacon and Sixth Streets. The photograph above was taken on June 5, 1926, at the Tumble-In-Café. The Pearl Harbor Café (below) continued business until the 1960s. However, this area was later redeveloped, and Filipino businesses appeared in Wilmington, Long Beach (along Santa Fe Avenue), and Carson (on Main Street). The barbershops, like the Olympic Barber Shop owned by D. Salvador, on the left below, also served Filipinos secondarily as underground betting bookies. (Both courtesy of San Pedro Historical Society.)

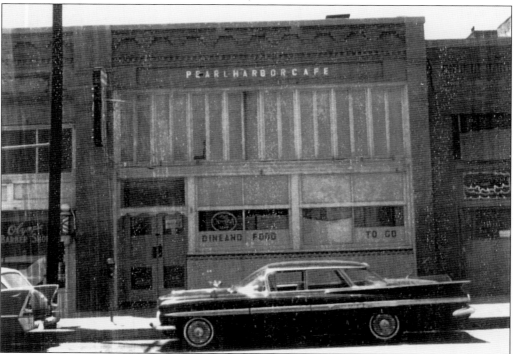

(Registration card, handwritten, partially legible)

1. Isidro Canlas — 30
2. 1039 Appleton Long Beach Calif
3. May 15th 1888
4. (1)
5. Bacolor Pampanga P.I.
7. Teamster
8. Geo. M. LaShell Long Beach Calif
9. No
10. Single — Malay
11. Calif
12. No

Isidro Canlas

1. Medium — Slender
2. Black — Black — No
3. No

J. L. Probst

19 Long Beach
Los Angeles Co.
California
June 5-1917

This form shows the first person in Long Beach to register for the U.S. Army for World War I was Isidro Canlas, a Filipino. Isidro was born in Bacolor, Pampanga, and arrived in 1905 at Buffalo, New York. The next year, he traveled to Denver, Colorado, to be a student and worked as a muleskinner. He followed his employer to Long Beach, California, in 1910 and in 1930 worked as foreman for a cement plant. When told (below) he could not marry Lydia Davalos in 1917 he said, to the Long Beach *Press-Telegram*, "This is my country, even though the clerk at Los Angeles figures me out as unfit to marry a girl from Mexico." They were married in Tijuana because, at that time, California laws prevented interracial marriages. He was classified as Malay, and she was considered white. (Both courtesy of Eloisa Gomez Borah Research Collection.)

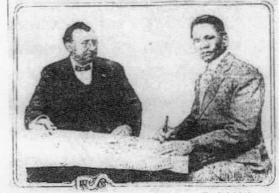

THE LONG BEACH PRESS, THURSDAY, JULY 5, 1917

NATIVE FILIPINO WAS FIRST TO REGISTER; THEN DENIED RIGHT TO MARRY IN THIS COUNTRY

ISIDRO CANLAS, 1039 Appleton Street, won well deserved fame in Long Beach June 5 of this year by staying up all night in order to make sure of being the first man to register for possible war draft in his precinct. The above photograph was taken at the registration desk of John L. Probst at the polling place of that day, 1171 Appleton street. Canlas, native Filipino, here employed by George M. LaShell, builders' supply contractor, had traveled 8000 miles to make certain of living under the protection of the Flag which he had come to revere in his native land.

Next comes a bit of technical irony.

Canlas met here and loved Miss Lydia Davolos, a beautiful Mexican girl. Isidro never had much use for Mexicans, as a class, but he simply couldn't resist her, as herself.

Wherefore, Isidro and Lydia went to the county seat to get a marriage license.

The Cupid factorum at the county seat denied them the paper because he classified Canlas as a Malay. Cupid was protecting the Mexican girl against marriage with an "inferior," to-wit a Malay.

Isidro, recalling his prejudice against Mexicans and smiling forsooth, told his troubles to his employer, LaShell, who made a trip to the court house in the young man's behalf, without results.

Then Canlas' dander was up. He proposed to see the thing through. He and Lydia sent to Tia Juana, in the bride's own native country, and were married there.

"It cost me $40," said the groom upon his return from the honeymoon. "That was a hold-up, of course. They charged $40 for the license just because they knew they could get it, the cholo grafters; it's well worth it, of course; but I wish I might have left the money in our own country; I say 'our own' country and I mean it. This is my country, even though the clerk at Los Angeles figures me out as unfit to marry a girl from Mexico."

Mr. and Mrs. Toney M. Bitonio

requests the pleasure of your presence at a

Dance in honor of the Christening of their son

Albert Anthony Bitonio

at the Chamber of Commerce Auditorium

Sunday evening, February 6, 1938

7 p. m. to 12

Semi-Formal

Godfather
J. Steve Pandes

Godmother
Mrs. Lydia Dorosan

Because of the California anti-miscegenation laws forbidding whites to marry nonwhites, couples were forced to go out of state or to Tijuana to get married. Al Bitonio was the result of such a union. Born and raised in San Pedro, Al is now an archival assistant for the San Pedro Bay Historical Society. Here is the announcement card in San Pedro celebrating his baptism in 1938. Below, on the grass are baby Al and his father, Tony Bitonio, and standing are, from left to right, his mother, Mary Bitonio, and godparents, Steve Pandes and Lydia Dorosan. (Both courtesy of Al Bitonio Collection.)

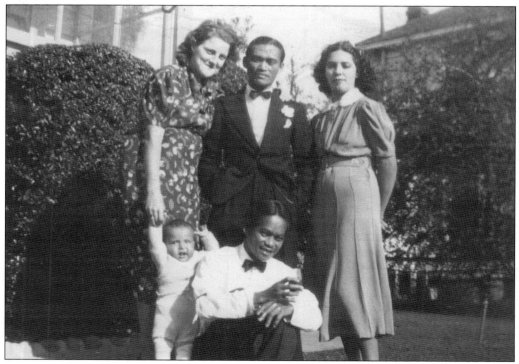

Marcelino Ines came as a labor contractor in 1920s along with his wife, Amalia. Working in Los Angeles and in the South Bay, they had their first child, Laura, in San Fernando, California, and later a son, Marcelino Jr., while in Stockton, California. Having been born in the United States, both Laura and Junior were American citizens. The family returned to the Philippines, and more children were added. (Courtesy of Laura Rossi Collection.)

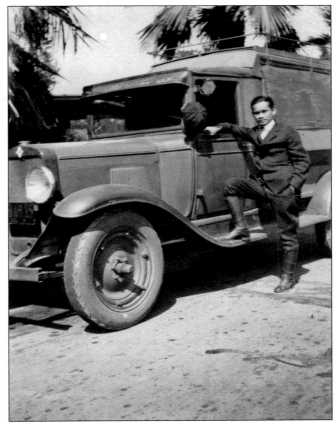

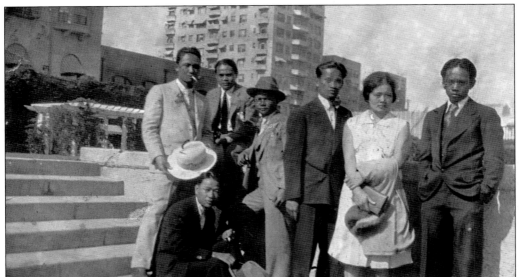

This photograph was taken in Long Beach in 1928. From left to right are unidentified, Eusebio Sotello, Fred Bayuga (kneeling), Santiago Inis, Castor Follosco, Marcelino and Amalia Ines, and Apolinario Inez. (Courtesy of Laura Rossi Collection.)

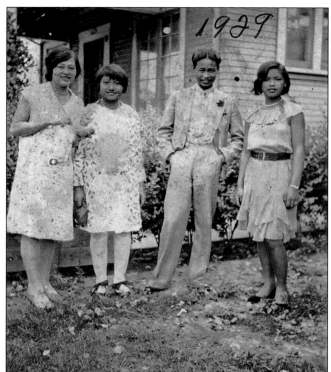

Filipina women were a rarity in the early immigration of Filipinos and as such were constantly courted by the many young bachelors here. This photograph was taken in 1929 in Long Beach with Amalia Ines (left) and Apolinario Inez (second from right) with two unidentified Filipinas. (Courtesy of Laura Rossi Collection.)

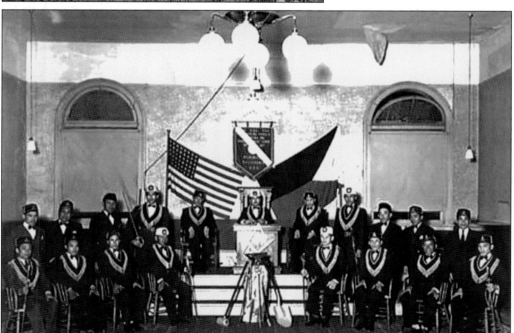

Here is a group photograph of members of the Filipino Lodge in Wilmington that was dated March 8, 1939, from Pyle's Photo Shop. (Courtesy of Shades of L.A. Archives/Los Angeles Public Library.)

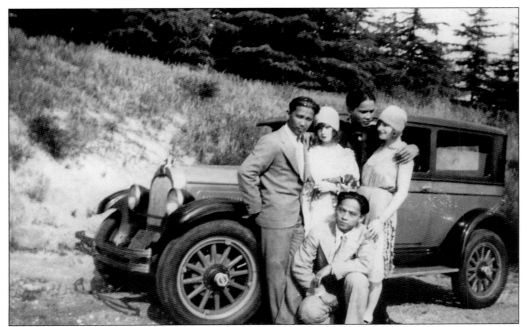

Many of these young Filipino men of the 1920s and 1930s were sharp dressers, were muscular from working hard, and had a style that women found attractive. Here Leoncio Villacorte on the left and his two partners have found two female friends to go riding in their automobile. In many cases, these workingmen would pool their money and share a car or share stylish suits to enable all of them to go out on dates. (Courtesy of ZoAnn Villacorte-Laurente.)

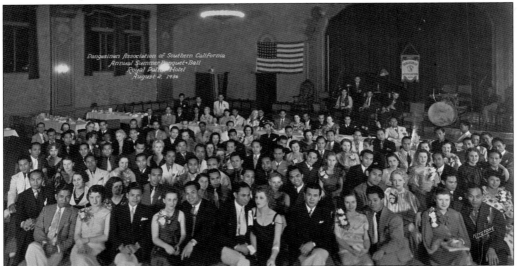

The Royal Palms Hotel in Rancho Palos Verdes, California, was in its heyday (1920s and 1930s) a popular hot sulfur springs spa and beach resort operated by Japanese immigrants until the Long Beach earthquake of 1933 and the Depression forced its closure in the late 1930s. Shown here is the Pangasinan Association of Southern California holding its Annual Summer Banquet-Ball on August 2, 1936. (Courtesy of Candelario Collection, Visual Communications Photographic Collections.)

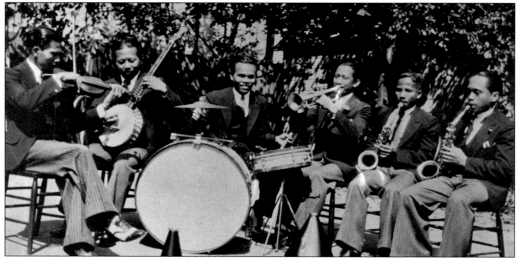

Doroteo Ines, seen here playing the trumpet, was born in Sinait, Ilocus Sur, in 1908 and came to the United States in 1928. He was a graduate of Chapman College and received his master's degree from USC in cinematography, where he created perhaps one of the first Filipino American films, *A Filipino in America*, in 1937 (a silent black-and-white film). He was active in the early Filipino community, serving as the first president of the board for the Filipino Christian Church and president of the United Filipino Community Association of Southern California. In this photograph, he served as director of the Mahi Oriental Band, which played in Long Beach and could be heard on the radio. (Courtesy of Royal Morales Collection.)

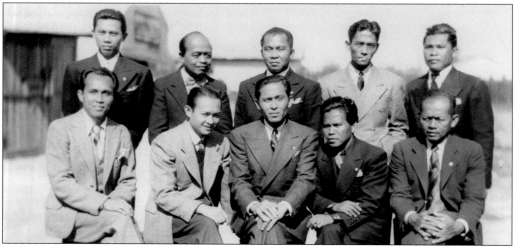

This photograph was taken of first-generation Filipino immigrants, all born and raised in the Philippines. It was taken sometime between 1930 and 1937 in the Los Angeles Harbor area. Romy Madrigal (top row, second from right) raised a family in Los Angeles and became president of the Filipino Community of the L.A. Harbor Area. Dodo Zamorano (top row, second from left) lived in the house. Bonifacio Libre (seated center) also became a president of the Filipino Community of the L.A. Harbor Area. ? Arendien (sitting right) owned Our Café, a Filipino restaurant near Sixth and Beacon Streets in San Pedro. All the men spoke the same common dialect of Cebuano and worked in the fish canneries located on Terminal Island. (Courtesy of Shades of L.A. Archives/ Los Angeles Public Library.)

Sylvester Cariaso was born on Christmas Eve 1905 and came to America at the age of 17. He worked first in Hawaii and Chicago and then the South Bay after serving in the U.S. Army Air Corps. While in the Los Angeles area, he shared a small house with other young Filipino men. (Courtesy of Ana Cariaso Collection.)

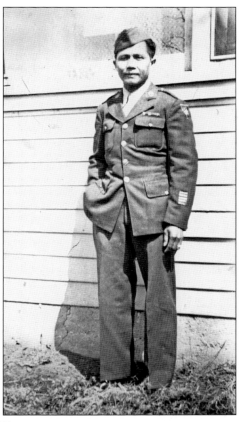

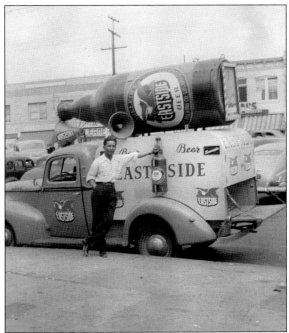

Sylvester Cariaso worked many jobs, including some time on the railroad. He finally worked in the naval shipyards on Terminal Island until he retired. In 1953, he married Ana Ines and bought a house in Compton, just north of what is now Carson. Together they raised two children, Sylvester Jr. and Carol. (Courtesy of Laura Rossi Collection.)

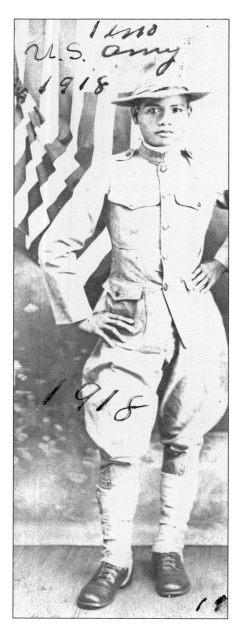

Florentino Akiaten joined the U.S. Army and was stationed at Schofield Barracks, Hawaii, in 1918. To his family, it seemed he was always in the military. He later served in both the Merchant Marines and U.S. Navy. He also settled down with his love, Ester, and together they raised a family in San Pedro, Long Beach, and Los Angeles. However, Ester's Caucasian family ostracized them and their five mestizo children. In 1936, Akiaten (below, right) is seen here enjoying a cigar with a friend in San Pedro. (Both courtesy of Shirley Akiaten-Chrisman Collection.)

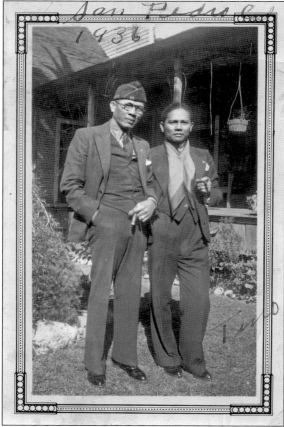

LIST OF UNITED STATES CITIZI

(FOR THE IMMIGRATION AUTHORITIES)

S. S. CALAWAII *sailing from* HONOLULU T. H. , AUGUST 15th. , 19 25 ,

No. or Line.	NAME IN FULL		AGE.		Sex.	Married or Single	IF NATIVE OF UNITED STATES INSULAR POSSESSION OR IF NATIVE OF UNITED STATES, GIVE DATE AND PLACE OF BIRTH (CITY OR TOWN AND STATE).		IF NAT
	Family Name.	Given Name.	Yrs.	Mos.					
1	Honculada	Situino	25		M	S	April 27th. 1900.	Danis, P. I.	✓
2	Hart	Edward A.	25		M	S	April 10th. 1901.	Mathdaysburg, Penn.	✓
3	Hotohot	Faletin	25		M	S	Dec., 4th. 1900.	Mobine Bohol, P. I.	✓
4	Ibanez	Cleto	21		M	S	April 23rd. 1904.	Sinait, P. I.	✓
5	Johnson	M. Johnson	44		M	S	Nov., 13th. 1880.	Baltimore, Md.	✓
6	Jose	Luis	25		M	M	Aug., 15th. 1900.	Laoag, P. I.	✓
7	Kearney	Ross P.	19		M	S	Sept. 27th. 1905.	Raton, N. M.	✓

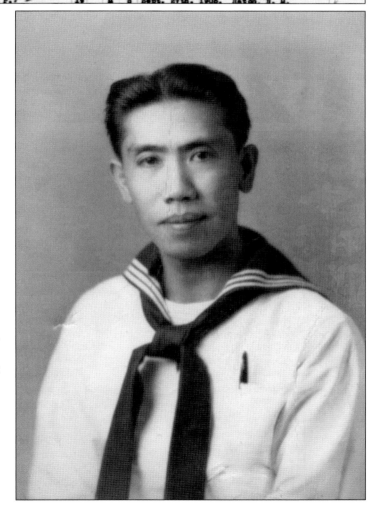

The record shows the arrival of Cleto Yabes Ibanez (fourth line) on the SS *Calawai* from the Philippines by way of Honolulu on August 22, 1925. Originally coming to study, Cleto, like so many other of his countrymen, had to find work to survive. He and his brother David and cousin Pedro rented a small bungalow and shared it with other young Filipinos. They worked various jobs, including farming, cooking, and as houseboys and even sometimes for Hollywood stars like Laurel and Hardy. Cleto, right, joined the U.S. Navy the day of the attack on Pearl Harbor and served as a chief steward aboard the aircraft carrier USS *Shangri-La*. He later brought Laura Ines as his war bride from Siniat, Ilocos Sur, to Los Angeles, and they had a son, Florante Peter Ibanez, in 1951.

19

Francisco Inez, on board with his compadre (godparent to one's child or very close friend) Gaspar Lagmay, was a naval veteran for 28 years. On April 1, 1943, he was taken prisoner by the Japanese in the Philippines. After being released from prison on November 6, 1943, because of illness and needing to recover from acute appendicitis surgery, he immediately joined a band of Philippine guerillas, where he fought until the end of hostilities. After he retired as a chief steward and chauffeur for Commodore Gene Markey, he attended the Long Beach Barber's College. Francisco was married to Maria Inez, and together they raised a daughter, Francine, in their home in San Pedro. (Courtesy of Dr. Francie Inez-Johnson Collection.)

Here Florentino Akiaten (left) is shown as a merchant marine aboard the SS *Chilsco* in 1930 with an unidentified shipmate. He rose to the rank of chief steward. (Courtesy of Shirley Akiaten-Chrisman Collection.)

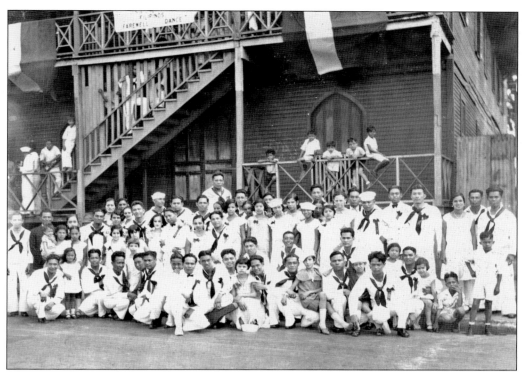

This gathering of new Filipino recruits for the USS *California* was taken as they assembled for a farewell party in the 1930s. They were headed for San Pedro, California, which was designated as the U.S. Navy Battle Fleet Home Port from 1919 to 1940. By 1934, a total of 14 battleships, 2 aircraft carriers, 14 cruisers, and 16 support ships were based at San Pedro. On April 1, 1940, the Pacific Fleet battleships sailed to Hawaii for annual fleet exercises and remained until the Pearl Harbor attack. (Courtesy of Dr. Francie Inez-Johnson Collection.)

This letter was written in November 1935 by chief steward Francisco Inez to plan a December social event for the Filipino crewmen onboard the USS *West Virginia* while stationed in San Pedro. (Courtesy of Dr. Francie Inez-Johnson Collection.)

UNITED STATES FLEET
BATTLESHIPS, BATTLE FORCE
U. S. S. WEST VIRGINIA, Flagship

San Pedro, California,
19 November 1935.

TO ALL MY SHIPMATES:

I suggest that the Filipinos on board the U.S.S. WEST VIRGINIA have and form a social dance to be given sometimes next month in order that we may form a good and perfect friendship and acquaintance for each other. This proposed dance cannot be successful without your financial support so let us go shipmates. Show your faithful cooperation and the spirit of your good ship WEST VIRGINIA.

The proposed contributions will be divided into three classes as follows:

(1) STEWARDS & COOKS - - - - - - - -$4.00
(2) MATT1c, 2nd, XXXXX class - - - - 3.00
(3) MATT3c- - - - - - - - - - - - -2.00

F.D. INEZ
CHAIRMAN & TREASURER.

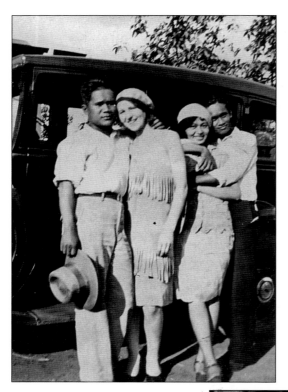

Marcelino Ines was one of the few Manongs of his time able to bring his young bride, Amalia, (couple on right) with him to America. It was considered improper for single Filipinas to travel alone, especially to a land of so many single men. Usually those men with wives left them in the Philippines with their families with the anticipation that they would be going home rich from their work in Hawaii and the mainland. The couple on the left is Castor and Laverne Follosco, godparents to the Ineses' first child, Laura (below left). (Courtesy of Laura Rossi Collection.)

With so few Filipina women in America, there were few full-blooded Filipino children born here. Marcelino and Amalia Ines's love produced Laura (standing), born in San Fernando in 1929, and Marcelino Jr. (in stroller), born in Stockton in 1931. Both children were destined to return to America and raise families in Wilmington and Carson after World War II. (Courtesy of Laura Rossi Collection.)

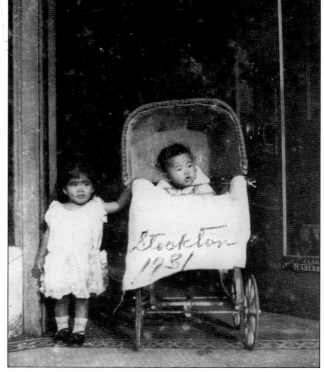

Pictured here in Long Beach is a young Filipino who worked as a bellboy in the Long Beach hotels in the 1930s. (Courtesy of Reyes Collection, Visual Communications Photographic Collections.)

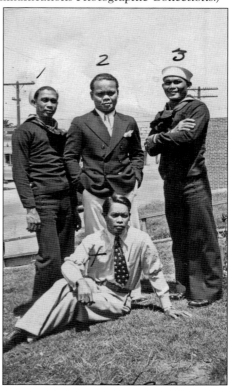

Tony Bitonio (3), a navy man who served on the USS *North Hampton*, poses with his friends Zachartius Torbio (1), Niebres ? (2), and Abad ? (4) in San Pedro in 1932. Prior to and during World War II, many Filipinos were recruited to the U.S. Navy but could not rise above the rank of steward. They served as cooks, personal houseboys, and drivers for U.S. Naval officers. However, by the late 1960s, Filipinos had strived to advance in the ranks beyond steward. (Courtesy of Al Bitonio Collection.)

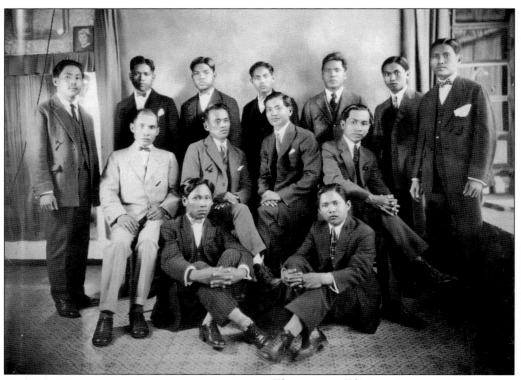

These young Filipino pioneers came to America from the towns of Pasugquin and Laoag, Ilocos Norte, in the 1930s. From left to right are (first row) Marcos Balatico and Pedro Garaci; (second row) Julio SaHagun, Ramon D. Labuguen, Enrique D. Labuguen, and Pedro G. Agluqub; (third row) Fausto de Luna, Ramon Galiba, Norberto Domaguing, Santiago Udasco, Julio Aguda, Antonino G. Labuguen, and Florencio Perulta. (Courtesy of Marie Jo SaHagun Taitague.)

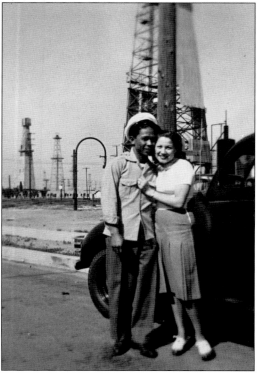

The Long Beach area is rich with oil, especially on Signal Hill. Here Bernard Daquioac stops with a friend in front of the many oil wells of the area in the 1930s. (Courtesy of Reyes Collection, Visual Communications Photographic Collections.)

Two

GROWING UP AS

AMERICAN-FILIPINOS

1940s–1950s

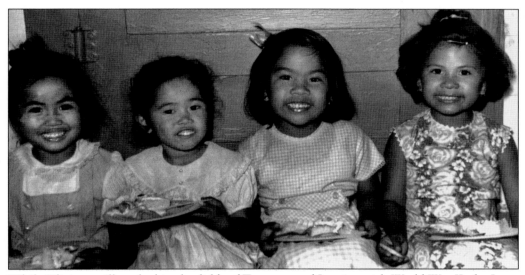

While Filipinos still worked in the fields of Torrance and Lomita, with World War II, the Long Beach Naval Operating Base, Naval Air Station, and Naval Shipyard (all on Terminal Island) became the home port for many Filipino American sailors, and Fort MacArthur in San Pedro had facilities open to use by all military families as well as Filipino American veterans and organizations such as the United Filipino American Services Organization (UFASO). The number of Filipino American families grew, especially with the influx of Filipina war brides brought over following World War II. In 1946, Filipinos joined together and formed the Filipino Community of Los Angeles Harbor Area, Inc. The next year, they bought land and built what was believed to be the largest and first Filipino community hall in the United States. With the building of new tract homes, Filipinos living in Los Angeles began to move to newer homes in the South Bay and other suburban areas. Retired career military men and women also decided to stay in the area and sent their children to local schools. In most cases, the Pilipino dialects were not passed on to their children, as they believed assimilation into the American mainstream was more important. Parents only wanted the best for their children, and the passing of culture and history became effectively limited to Filipino food and replaced with family pressure toward higher education and careers. Here are American-born Filipinos, from left to right, Carol Cariaso, Leilani Ines, Rosie Apostol, and an unidentified friend enjoying birthday cake and ice cream in the 1950s. (Courtesy of Apostol Family Collection.)

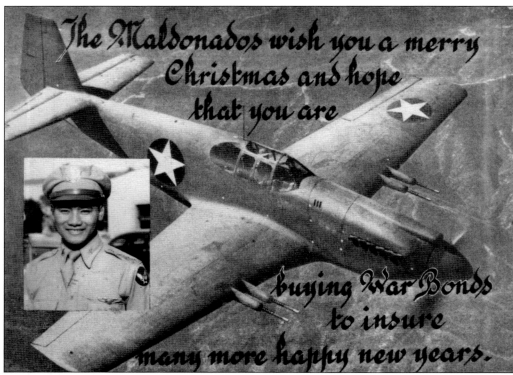

The Maldonados wish you a merry Christmas and hope that you are buying War Bonds to insure many more happy new years.

Lt. Mario Maldonado of the Army Air Corps sent this Christmas postcard to Tawa Desuscido during World War II. He later married Emily Yatko, and although they lived in Los Angeles, the couple was very popular in the South Bay circles of families. Among Filipinos of that era, there was no real distinction about where in Los Angeles someone resided. Everyone seemed to know each other. (Courtesy of Tawa Desuacido Collection.)

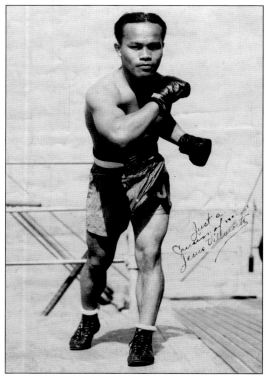

Navy bantamweight champion Jesus "Jimmy" Villacorte strikes his boxing pose while aboard ship for the camera. Born in Palo, Leyte, Jimmy joined the navy in the Philippines along with his brother, Leoncio, in the 1920s and, like most navy men, moved from ship to ship and port to port, including Long Beach. His last port of call was San Diego, where he retired in the 1950s, bought a bar and restaurant, named it the PI Café, and finally married late in his life. (Courtesy of ZoAnn Villacorte-Laurente family.)

Tawa Desuacido, although born in Stockton, has lived most of her life and raised her family in the South Bay and Carson and with her teenage relatives and friends found recreation at the Long Beach Pike and local dances. She was also asked to bring her Filipina girlfriends to Fort Cook during World War II to be dance partners for the 2nd Filipino Infantry Regiment, stationed and in training in central California to return to the Philippines and secretly pave the way for General MacArthur's promise to return. (Courtesy of Tawa Desuacido Collection.)

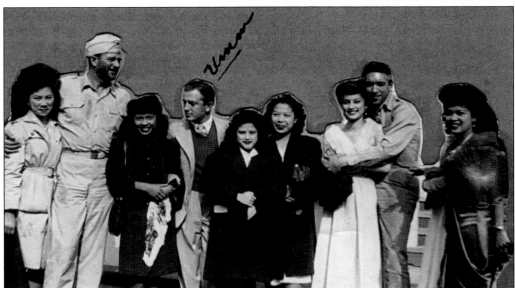

The 17-year-old Tawa Desuacido (third from left, between John Wayne and director Edward Dmyrtyk) quite unexpectedly was cast in the film *Back to Bataan*, starring Wayne and Anthony Quinn. While on her way to class at Los Angeles City College, she was asked to give a ride for some Filipino children to a casting call for the movie, but instead of them, it was Tawa who became hired as an extra. While on the set, she became fast friends with the cast and crew and earned the nickname "Jitterbug" for her dancing ability. (Courtesy of Tawa Desuacido Collection.)

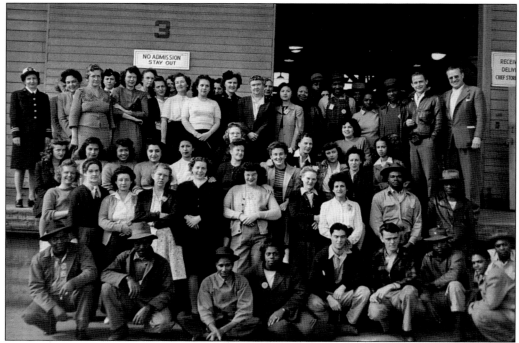

Filipinos were among the many civilians working at the San Pedro Naval Supply Depot in this photograph. (Courtesy of Tawa Desuacido Collection.)

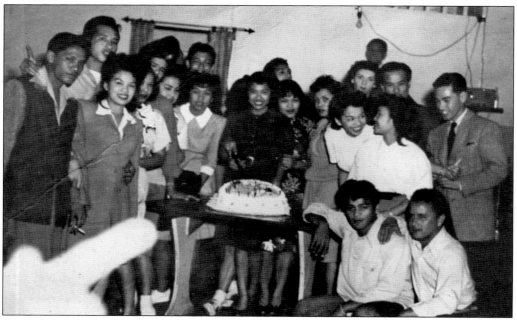

A. Andres, owner of the LVM (Luzon-Visayas-Mindano) Café in San Pedro's Beacon and Sixth Streets area promised to host a party for the first local teenager whose birthday was coming up next. Tawa Desuacido happened to be that lucky youth and is pictured here with her many friends behind the cake in March 1946. (Courtesy of Tawa Desuacido Collection.)

During the wedding of Marcy and Johnny Cruz, the boys decided to play baseball. Fred Balcena (brother to Bobby Balcena, baseball legend) is catcher for the groom, Johnny Cruz, at bat. Unfortunately for him, a ball went through a garage window. (Courtesy of Tawa Desuacido Collection.)

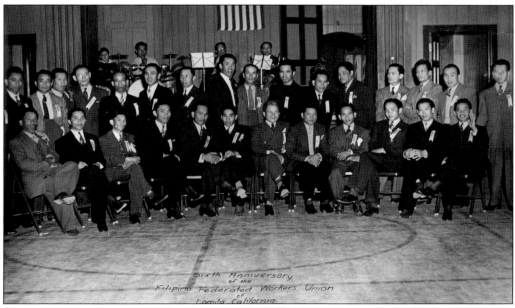

Shown is the gathering of members during the sixth anniversary of the Filipino Federated Workers' Union of Lomita, California, and is dated April 12, 1941. Seated second from the left is Sylvester Cariaso. (Courtesy of Ana Cariaso Collection.)

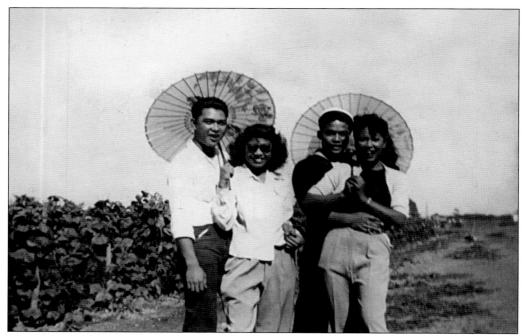

This photograph was taken at a picnic on the Filipino farm owned by the Asis family, on what is now 223rd Street and Avalon Boulevard in Carson, in the late 1940s. Tawa Desuacido (second from left) and her girlfriend, Leimoni Dagampat, pose with boys met that day. (Courtesy of Tawa Desuacido Collection.)

Cathy Ines stands in front of the Narvacan Hall where she was married to Jimmy Ines. The farm was owned by the Narvacan Association in what is now Carson, and because it served well for Filipino parties, it was regularly rented out to members and other Ilocanos. Goats and hogs were raised here to be sold for parties as well as roosters for cockfights. (Courtesy of Ines family.)

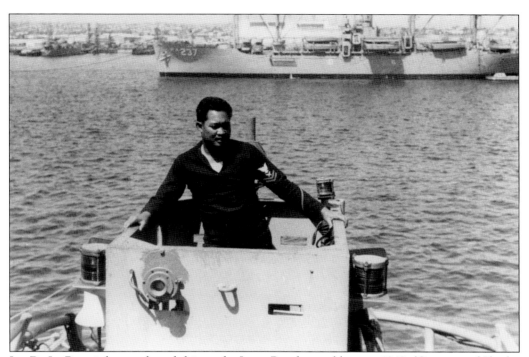

Joe De La Rosa is here onboard ship at the Long Beach naval base in 1942. (Courtesy of Shades of L.A. Archives/Los Angeles Public Library.)

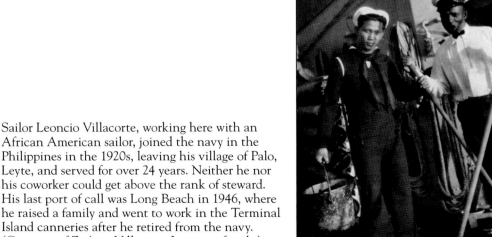

Sailor Leoncio Villacorte, working here with an African American sailor, joined the navy in the Philippines in the 1920s, leaving his village of Palo, Leyte, and served for over 24 years. Neither he nor his coworker could get above the rank of steward. His last port of call was Long Beach in 1946, where he raised a family and went to work in the Terminal Island canneries after he retired from the navy. (Courtesy of ZoAnn Villacorte-Laurente family.)

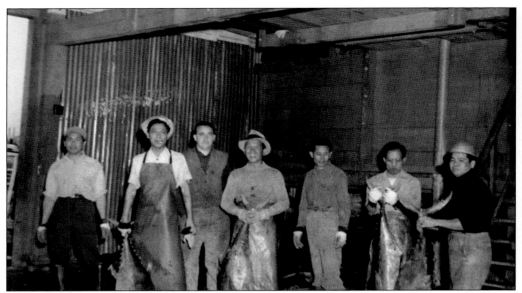

Pictured here is the tuna crew of Starkist Cannery on Terminal Island. Many Filipinos as well as Mexicans and others got jobs in the many canneries on the island. Initially the fishing industry here began with Japanese Americans and their fishing skills. Mostly Filipino men worked on the mackerel and tuna, and Japanese women worked on the cutting machines for the sardines. Pay was about 45¢ an hour. However, with World War II, all the Japanese Americans were removed from their Terminal Island village to internment camps. (Courtesy of ZoAnn Villacorte-Laurente family.)

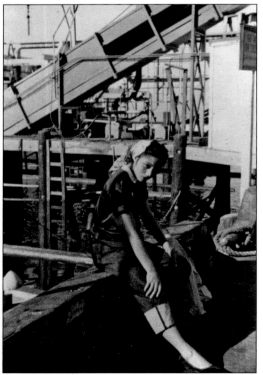

Women also played a major role in cannery work. Natividad Abella, a second-generation Filipina working at Terminal Island, is shown taking a break in 1948. Most women on the line wore a white uniform and were sometimes joking referred to as fish nurses. The fish canneries flourished until the last one, Chicken of the Sea, closed in 2001. (Courtesy of Shades of L.A. Archives/Los Angeles Public Library.)

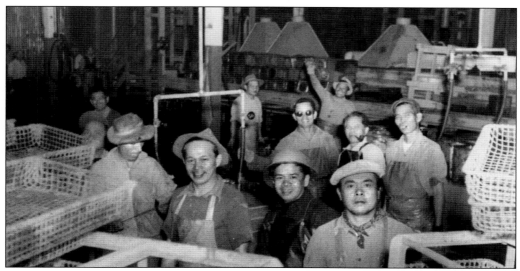

While the canneries provided steady work, they also had their hazards. Photographed around 1955, Leoncio Villacorte (in the background raising his hand) had lost a finger among all the cutting blades and conveyor belts used to process raw fish for cooking to canning. As a cannery worker, he and others joined the International Longshore and Warehouse Union (ILWU). (Courtesy of ZoAnn Villacorte-Laurente family.)

CALIFORNIA SHIPBUILDING CORP
International Brotherhood of Boilermakers, Iron Shipbuilders Welders and Helpers of America
Local No. 92
TRAINEE CARD

Name......... Brown, Helen Summers

Badge No.........

Present Class ... One Position

Starting Date 1st period... 4-14-43

Rate of Pay... $1.05

Starting Date 2nd period.........

Rate of Pay

Starting Date 3rd period.........

Rate of Pay

New Class

Rate of Pay

Approved

By

By

Local No. 92

(MEMBER'S RECORD)

No. 10576

HELEN S. BROWN

IS EMPLOYED BY

CALIFORNIA SHIPBUILDING Corporation

WILMINGTON, CALIFORNIA

10576

SECTION 529 OF THE PENAL CODE OF CALIFORNIA PROHIBITS THE USE OF THIS CARD BY ANY PERSON OTHER THAN THE ONE NAMED HEREIN AND WHOSE PICTURE APPEARS HEREON.

SIGNATURE OF EMPLOYEE
Helen S. Brown

ISSUING OFFICER

GENUINE ONLY IF WATERMARKED CALSHIP

| 1 2 3 4 | 1 2 3 4 | 1 2 3 4 | 1 2 3 4 | 1 2 3 4 | 1 2 3 4 |

WORKING CARD
BOILERMAKERS' UNION, LOCAL 92
LOS ANGELES, CALIFORNIA

Date 4-13-43

Name Helen Summers Brown

Qualification Weeder Jr.

Secy.

| JULY | AUGUST | SEPT. | OCT. | NOV. | DEC. |

The Naval Shipyard was also on Terminal Island, and during World War II, Filipina women joined the war efforts and joined unions, too. Helen Summers Brown, even after earning her bachelor's and master's degrees in education from UCLA in 1937, was a card-carrying member of the Boilermakers Union as a welder. (Courtesy of Shades of L.A. Archives/Los Angeles Public Library.)

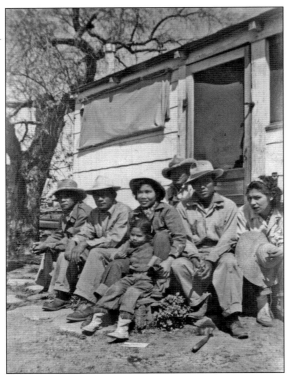

Gathering on the porch, the Apostol family and workers rest from farm work. Although they worked on a farm on 190th Street and Crenshaw Boulevard in Torrance, their home was in Carson. Their house still stands on 213th Street near Delores Avenue. A housing tract in the 1960s was built around their property, which before had stood alone on a small hill alongside another single home owned by Cleto Baldonado. Today these two homes blend in with the tract homes all at the same level on the street. (Courtesy of Apostol Family Collection.)

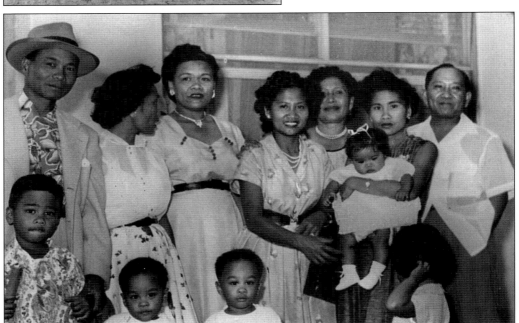

Here is another one of many Filipino children's birthday parties at the Apostol home. The Apostols raised two girls in Carson, Rosie and Jo Ann. For their generation of baby boomers with all the compadres and relatives, it seemed like there was a Filipino party almost every weekend. (Courtesy of Apostol Family Collection.)

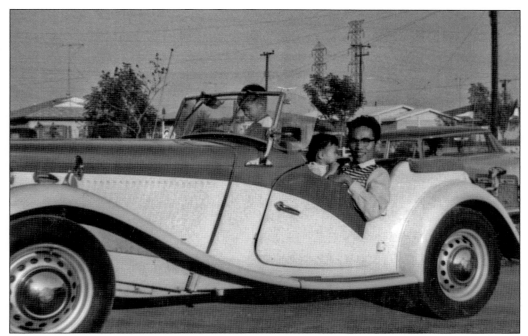

Filipinos were not only known to be smart dressers; they also liked stylish automobiles. Here driver Marcelino Ines Jr. takes his nephews for a spin in Wilmington in a late-1950s MG sports car. (Courtesy of Laura Rossi Family Collection.)

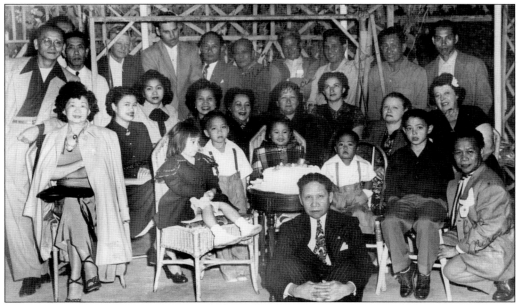

An early birthday of Francie Inez is celebrated in her parents' San Pedro home on November 20, 1949. Their outdoor patio was the site of many parties. Francie grew up in San Pedro and later became a doctor of child psychology, opening her practice back in San Pedro and raising her children as a single mother. Dr. Francie also is involved in local nonprofit community youth organizations. (Courtesy of Laura Rossi Family Collection.)

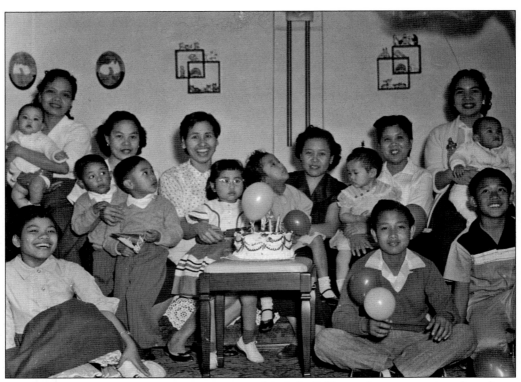

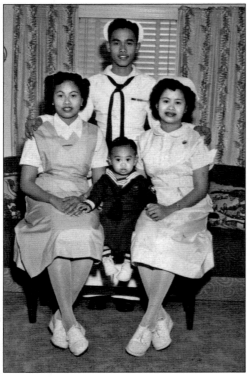

Marie Jo SaHagun (center, wearing glasses) has her birthday in Torrance in the 1950s among family, friends, cake, and balloons. Marie attended Narbonne High and became a student leader in the formation of the Pilipino American Coalition at Cal State University Long Beach. (Courtesy of Marie Jo SaHagun-Taitague.)

Laura Ines Rossi (right) and her sister Ana Ines Cariaso (left) came after World War II, took nursing classes, and worked at St. Francis Hospital. Their brother, Marcelino Ines Jr. (standing), was born in Stockton, California, and Laura was born in the San Fernando Valley (a suburb of Los Angeles). Ana was born in the Philippines after their parents returned there in the early 1930s. Laura returned to the United States as a war bride in 1949 at the age of 17, had a child (seated), got divorced, and moved to Wilmington to buy her own home with $1,500 she received as a war reparation claim. She later remarried and raised a family of five children. She still resides in the same home she bought with her own money in 1953. (Courtesy of Laura Rossi Family Collection.)

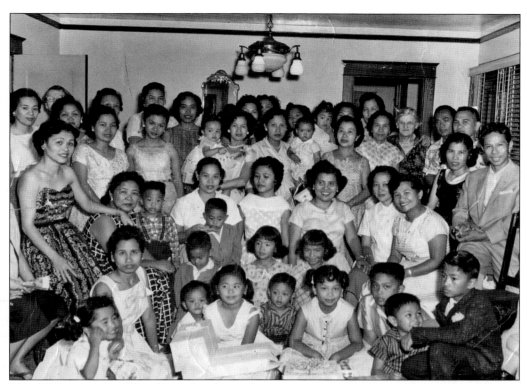

Here Wilmington and San Pedro families gather for yet another party during the 1950s. Many Filipino parties included musical instruments, singing, playing cards, and mahjong. But the main appeal was always the Filipino food dishes. Hosts took pride in the delicious homemade dishes brought in by different relatives and friends. (Courtesy of Marie Jo SaHagun-Taitague.)

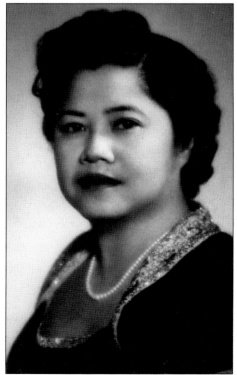

Primitiva Demandante Doromal, M.D., was awarded a Barbour Scholarship to study in the United States, and from 1938 to 1941, she earned her medical degree from the University of Michigan at Ann Arbor. Dr. Demandante passed the California Medical Board Exam in 1941, becoming the first Filipina physician licensed to practice medicine in the state of California and the United States. She was chief of the medical staff at Carson Hospital in 1967. She served patients from families who worked in the naval shipyards in Long Beach and the surrounding communities. She also made time to entertain important community guests, such as writer Carlos Bulosan, and served on the board of the Filipino Community of Los Angeles Harbor Area, Inc. She passed away in 1971. (Courtesy of Dr. Ruth Demonteverde Family Collection.)

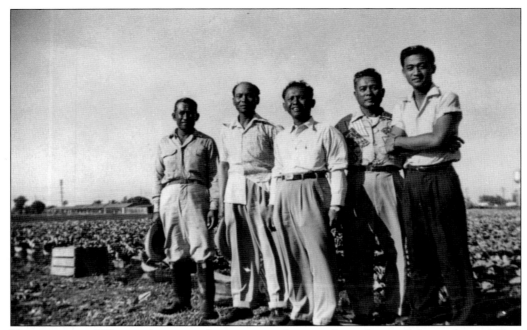

Here a group of Filipino American farmers pause from work on the small 3-acre farm of Tom Reyes (second from left) in Torrance, near 182nd Street and Yukon Avenue, in May 1949. Rev. Juan Santos is standing at center, and Lito Gorospe is at the far right. (Courtesy of Shades of L.A. Archives/Los Angeles Public Library.)

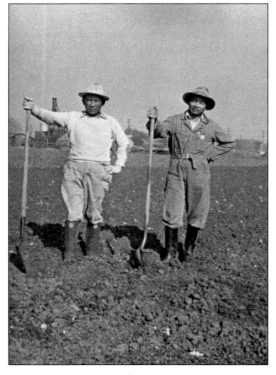

Pictured here are, from left to right, Tom Reyes and Bill Valbunena on the Reyes Torrance larger, second farm in 1954. Tom and Priscilla Reyes farmed this property from 1951 till 1956. (Courtesy of Reyes Collection, Visual Communications Photographic Collections.)

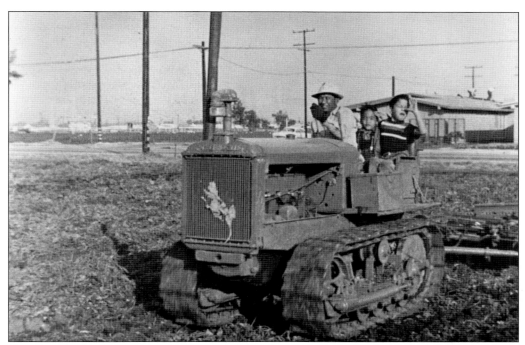

Tom Reyes takes his nephews Rolley and David for a tractor work ride on his Torrance farm in the 1950s. (Courtesy of Reyes Collection, Visual Communications Photographic Collections.)

Adelaida Igarta "Deling" Ibanez does her own farm work in her home garden in Gardena. She came to study at Cal State University Long Beach in 1955 and was already a schoolteacher in the Philippines. Deling married Pedro Ibanez in 1957 and became a stay-at-home mom to raise their three children: Pedro Jr., Eloise, and Leila.

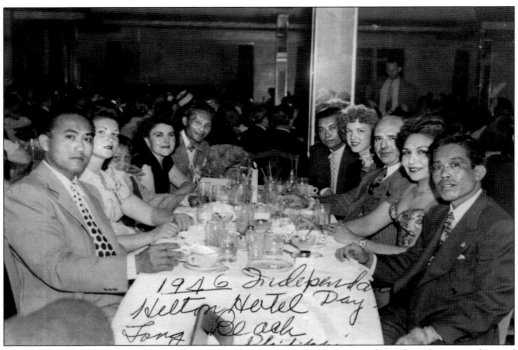

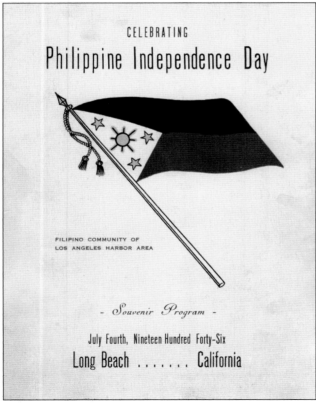

CELEBRATING

Philippine Independence Day

FILIPINO COMMUNITY OF
LOS ANGELES HARBOR AREA

- *Souvenir Program* -

July Fourth, Nineteen Hundred Forty-Six
Long Beach California

Some of the founding members of the Filipino Community Center of Los Angeles Harbor Area celebrate their first Philippine Independence Day on July 4, 1946, at the Long Beach Hilton Hotel. (The Philippine government later declared June 12 Philippine Independence Day with July 4 as U.S.–Philippines Friendship Day). The program booklet (below) lists among its officers Aproniano E. Elder, president; Bonifacio Libre, first vice president; E. De la Cruz and Nelle Roldan, secretaries; and Dr. Primitiva Demandante, treasurer. (Both courtesy of Kenny Dionzon.)

This listing of local Filipino businesses and Terminal Island canneries representatives appeared on the back of the Filipino Community Center of L.A. Harbor Area, Inc., program booklet for their first anniversary of the Philippine Independence Day. The celebration was held on July 4, 1947, at their Wilmington Hall Grounds at 323 Mar Vista Avenue. The program went from 10 a.m. to midnight and featured entertainment, picnic, athletic events, and dance with awards. This same general format was followed each year until the formation of the Filipino American Community of Los Angeles (FACLA), when Harbor members joined them in the annual FACLA July 4 Miss Philippines Queen Coronation and Dance at the Hollywood Palladium. (Courtesy of Kenny Dionzon.)

COMMITTEES FOR INDEPENDENCE DAY CELEBRATION

FINANCE COMMITTEE....Mr. Pete Paday, Chairman. Mr. Pedro Monteclaro, Assistant

Businessmen:

1.	Bohol Market	Felix Quinal
2.	Frisco Cafe	F. Ancheta
3.	Pearl Harbor Cafe	J. Del Resma
4.	Our Cafe	Fred Intong
5.	L. V. M. Cafe	A. Andres
6.	Vince's Portrait Studio	V. Vellega
7.	New Deal Barber Shop	C. Allenegui
8.	Tonar's Barber Shop	Tony Orofilla
9.	Olympic Barber Shop	D. Salvador
10.	United Barber Shop	Rubio & Tino
11.	Palos Verdes Barber Shop	A. De Ocampo
12.	Vince's Malt Shop	V. Ricardos
13.	Filipino Social Club	A. & P. Buenvineda
14.	Beacon Pool Hall	T. Trino

Representatives of various canneries:

1.	California Sea Food	V. Florencio
2.	South Pacific	B. Antoniano
3.	West Coast Packing Co.	Lawrence Foronda
4.	Coast Fishing	Paul Cristino
5.	French Sardine No. 1	Stanley Pulutan Reyno Boltiador Felix Cabanit
6.	French Sardine No. 2	Felipe Ragudo P. Supeciencia C. Sebastian
7.	Southern Calif. Pkg. Co.	T. Tucay
8.	Van Camp (N. K.)	L. Sebastian
9.	Franco-Italian	F. Lopez
10.	Terminal Island Sea Food	Cesar Pasqual
11.	California Marine	R. Madrigal
12.	South Coast Fisheries	Andy Cristobal Joe Lacio
13.	Pan-Pacific Fisheries	Fred Roldan Joe Tagle V. Catada

SOCIAL AND PROGRAM COMMITTEE....................Mr. Romy Madrigal, Chairman

REFRESHMENT & SERVICE COMMITTEE........Auxiliary Filipino Community of Los Angeles Harbor Area, Incorporated
Dorothy Gardner, President Pro Tem
Mr. Bonifacio Libre
Mr. E. Bob de la Cruz
Mr. V. Catada

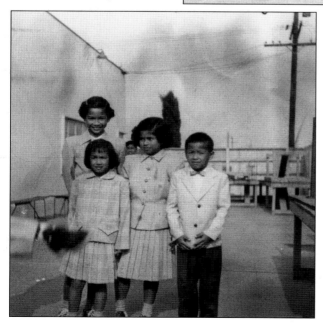

The Dagampat children stand in their Sunday best outside the back of the Filipino Community Center of L.A. Harbor Area in the 1950s. From left to right, they are Walene, Lynn, Paulette, and Mike Dagampat. (Courtesy of Mike Dagampat.)

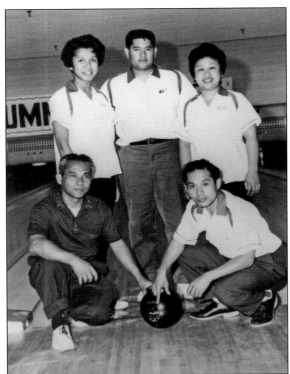

This bowling team photograph was taken in April 1961 during the Filipino Bowling League playing at the Cove Bowl on Pacific Coast Highway in Wilmington. From left to right are (kneeling) Vincent Gali and Joe Palicte; (standing) Karen ?, Bob San Jose (second-generation American-born president of the Filipino Community of L.A. Harbor Area 1967–1969), and Janet San Jose. (Courtesy of Shades of L.A. Archives/ Los Angeles Public Library.)

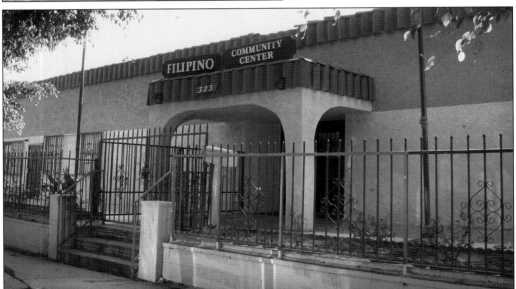

Today the Filipino Community Center of Los Angeles Harbor Area, Inc., still stands despite occasional repairs to its roof and has served over the years as a center for meetings, parties, and of course dances and queen contests. It still represents an embracing community, not restricted to a particular fraternal or regional organization but open to all Filipinos. This building, also known by the local youth as the "Flip Hall," also served as the Pilipino Youth Center (PYC) program in the 1970s, staffed by UCLA student volunteers.

Navy housing and access to the base commissary made it affordable for many Filipinos to support large families. Most also had a large freezer to be able to buy food on sale and store for later. Pictured here in the 1950s are Elaine Palma (left) on her 11th birthday with her stepdad, Felipe Lamug Sr. (right), and two unidentified neighbors in front of their Second Street navy housing in San Pedro. (Courtesy of Felipe Lamug Family Collection.)

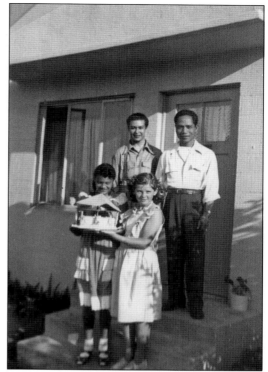

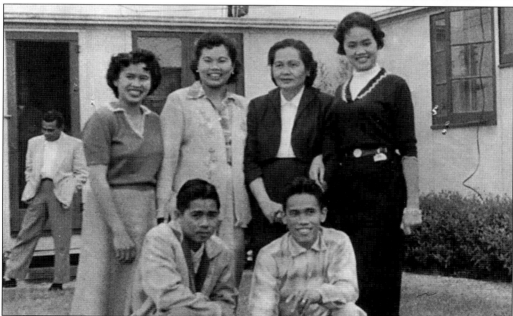

In 1956, the whole Ines family finally came together in the United States, joined by their mother and youngest brother, shown here in front of the navy housing in Wilmington. From left to right are (kneeling) Jimmy Ines and Marcelino Ines Jr.; (standing) Laura Ines Rossi, Ana Ines Cariaso, Amalia Ines, and Grace Ines Wolfe. (Courtesy of Laura Rossi Family Collection.)

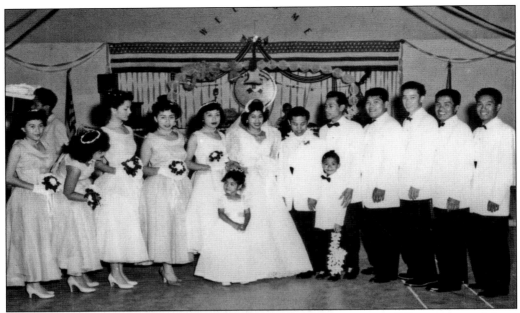

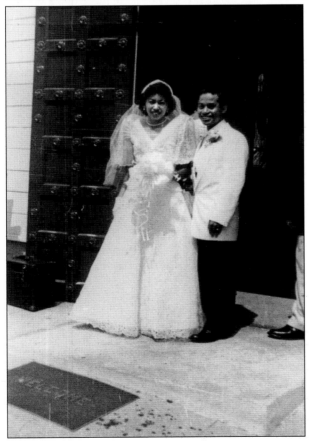

Here are two different views of the Palicte wedding on July 3, 1954. The top view is a group photograph of the bridal party. From left to right are Dee Tipay, Gloria Palicte, Gertrude Ocha, Louisa Bersola, Espi "Pickles" Curaza, Natividad Navares (bride), Joe Palicte (groom), Martin Nationalesta (the best man, shown holding his son, Martin Jr.), Chuck Versola, Jimmie Lee, Phil Ventura, and Oredo Bisquera. The flower girl in the center is Stephanie Palicte. This photograph was taken at the Filipino Community Center of Los Angeles Harbor Area. The left view is of the bride, Natividad Navares, and groom, Joe Palicte, standing outside St. Columban Filipino Catholic Church in Los Angeles. (Courtesy of Shades of L.A. Archives/ Los Angeles Public Library.)

Joe Palicte poses with his classmates and friends on the beach in Long Beach. From left to right are friend Clarence ? (Filipino and Portuguese from Hawaii), Joe Palicte, and friend Kim ? (Korean from Hawaii). These three young men were classmates of the National Automotive School in 1949. (Courtesy of Shades of L.A. Archives/Los Angeles Public Library.)

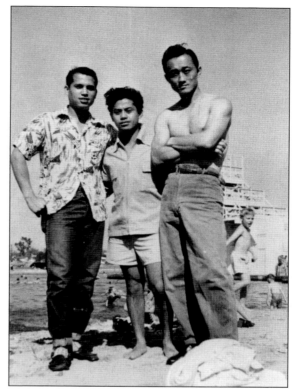

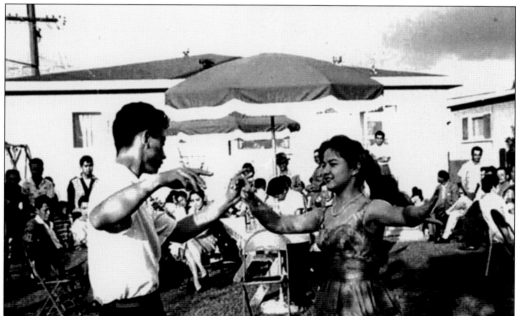

Pictured here are Bill and Sharon Sotello (brother and sister), dancing during the Rossi family christening celebration for Irma Rossi, held at her parents' home backyard in Wilmington in 1957. (Photograph by Marcelino Ines Jr., courtesy of Laura Rossi Family Collection.)

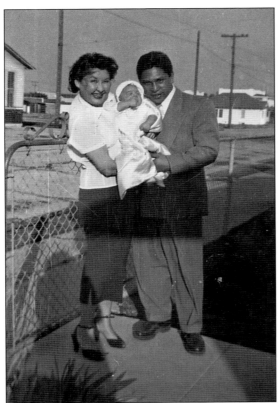

Esther and Norman Wakinakona were godparents to Felipe Lamug Jr. (center) in 1951 and are seen here in San Pedro. Across from this front yard was the Union Ice Company. Felipe Jr. was a mestizo (born of Filipino and Caucasian parents) but always considered himself a Filipino American. (Courtesy of Felipe Lamug Family Collection.)

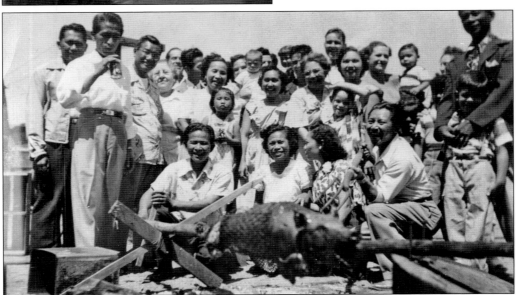

Captured here is a Filipino American family gathering on a Torrance farm with *lechon* (roast pig). Helen Brown, a mestizo, is in the back row (center, partially visible) holding a baby. Her husband, Bill Brown, a Caucasian, is in the very back row as the tallest person. (Courtesy of Shades of L.A. Archives/Los Angeles Public Library.)

Taking a much needed work break is the Pearl Harbor Café crew with Tawa Desuacido wearing the apron. The Pearl Harbor Café in San Pedro was owned by Fred Intong, and this photograph was taken on October 26, 1947. (Courtesy of Tawa Desuacido Collection.)

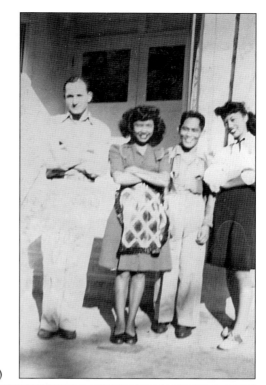

Pictured is the October 10, 1954, baptism party for Sylvester "Butch" Cariaso Jr. (baby held by parents with cap in center) in the family home backyard in Compton. Today Sylvester Jr. is an emergency room registered nurse at St. Francis Hospital. (Courtesy of Ana Cariaso Collection.)

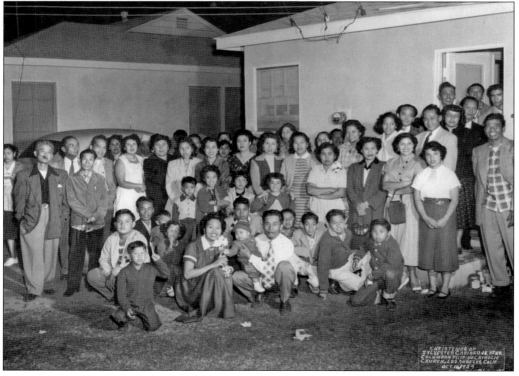

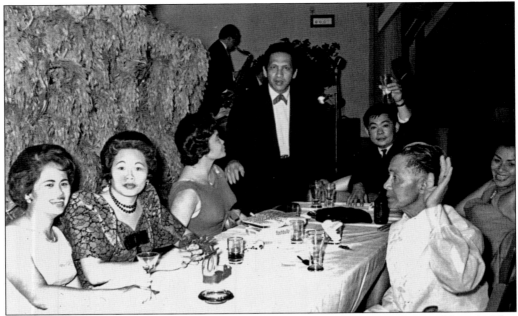

Many Filipinos in the late 1950s enjoyed going out dancing with their spouses and friends. This particular outing took place at the Non-Commissioned Officers Club (NCO) at Fort MacArthur in San Pedro. From left to right, they are Laura Ines Rossi, Ana Cariaso, Carol "Bebong" Alamares, Tony Alamares (standing), Tody Del Carmen (toasting), Sylvester Cariaso, and Mary Del Carmen. (Courtesy of Laura Rossi Family Collection.)

Mike Dagampat and his sisters pose by their navy housing unit in Long Beach during the 1950s. Mike later went on to become a student leader in the formation of the Pilipino American Coalition at Cal State University Long Beach in the 1970s. (Courtesy of Mike Dagampat.)

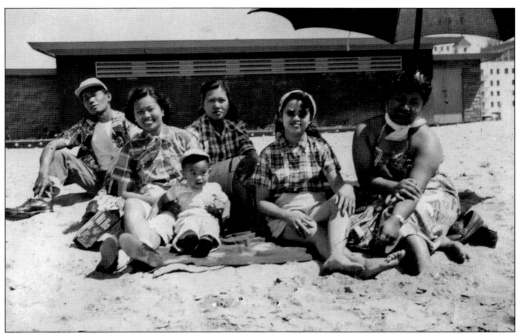

Enjoying the sun at Redondo Beach are, from left to right, Bill Tabag, Ana Cariaso, baby Florante Ibanez, Marquita Tabag, Laura Rossi, and an unidentified friend. Bill Tabag worked for many years and retired from the booming South Bay aircraft and aerospace industry after World War II. He and his wife, Marquita, raised two children, Sheila and Mario, in Wilmington. (Courtesy of Laura Rossi Family Collection.)

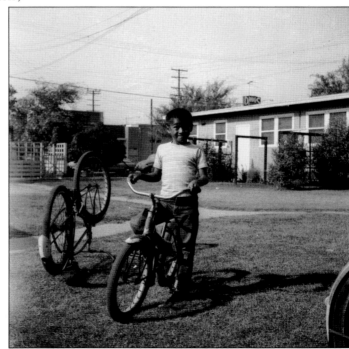

Biking was always fun and fast. Kids often would attach playing cards with wooden clothespins near their spokes to duplicate the roar of an engine. Here Mike Dagampat stops to pose for the camera while cruising though navy housing in the 1950s. (Courtesy of Mike Dagampat.)

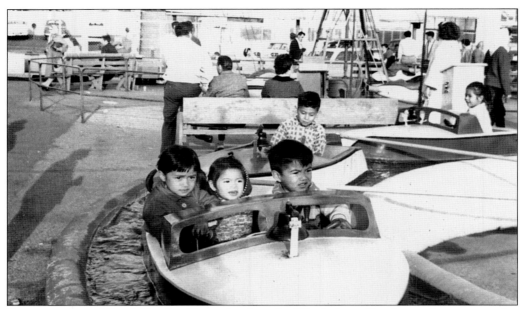

For generations of South Bay families and sailors, the Pike in Long Beach was the most popular local amusement park until it was demolished in 1979. While today there is a new Pike on the old grounds, it can't compare to the old Cyclone Rollercoaster, the Plunge (Indoor Pool), and the arcade games on the Midway. Onboard this kid's boat ride are, from left to right, Laurene Rossi, Irma Rossi, and George Rossi. (Courtesy of Laura Rossi Family Collection.)

In Wilmington, the Ines cousins gather for an early childhood picture in the late 1950s. They are, from left to right, Laverne Abrenica, Ralph Abrenica (kneeling), Irma Rossi, Leilani Ines, Carol Cariaso, Gwendolyn Abrenica, Jerry Rossi Jr., and Laurene Rossi. (Courtesy of Laura Rossi Family Collection.)

Three

RAISING FAMILIES AND GETTING INVOLVED

1960s–1980s

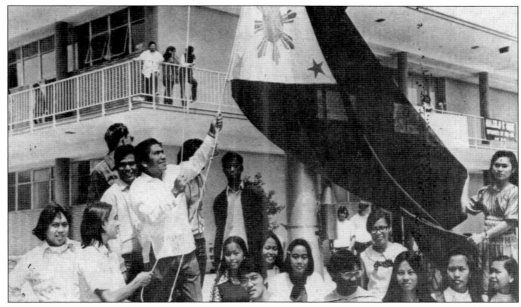

Filipino youth, the children of Manongs, also known as the "Bridge Generation," and children of second-wave military families grew up to the sounds of Lawrence Welk, the Beatles, and Motown. They also became caught up in the social movements of the 1960s and 1970s. From the call for civil rights and minority recognition came more college recruitment for these Filipino American youth. They formed Filipino clubs on campuses and pushed for ethnic studies. Long before the 1960s, Manongs had organized to form labor unions, but 1965 marked the start of the Great Grape Boycott initiated by Filipinos like Larry Itliong and Philip Veracruz, which later brought about the formation with Cesar Chavez of the United Farm Workers Union (UFW). With the 1972 declaration of martial law in the Philippines, American-born Filipinos called for an end to U.S. military aid to the Marcos dictatorship and were joined by recent immigrants. The 1965 change in U.S. immigration law allowed thousands of professionals and skilled technicians to come to America and are often cited as the "Brain Drain" of the Philippines. From 1971 to 1985, the community came together at annual F/Pilipino People's Far West Conventions (FWC) to discuss issues. South Bay leaders played leading roles in all these activities. Shown are the United Filipino American Students of Harbor Junior College raising the Philippine flag to signal the beginning of Filipino Cultural Week on May 31, 1972. (Courtesy of Royal Morales Collection.)

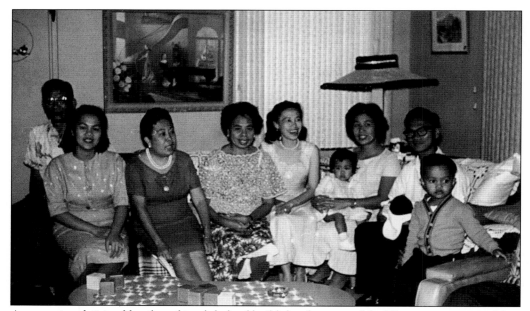

An occasional visit of family or friends helped build the closeness of the Filipino community. Here relatives and friends gather informally at the Inez residence in San Pedro in the 1960s. Hospitality was always offered and included food or snacks. Shown from left to right are Francisco Inez, Adelaida "Deling" Ibanez, unidentified, Gertrudes Quicho, unidentified, Eloise Ibanez, Francie Inez, Oscar Igarta, and Pedro Ibanez Jr.

Although they were all born in the Philippines and half Italian, some of the Rossi siblings attended Banning High School in Wilmington. In this 1950s picture are, from left to right, (seated) Jerry and Tony; (standing) Amelia, Alice, Leyte, Lillian, and Evelyn. Jerry Rossi served in the army during the Korean War and in 1954 married Laura Ines. Together they had four children: George, Laurene, Jerry Jr., and Irma Rossi. (Courtesy of Laura Rossi Collection.)

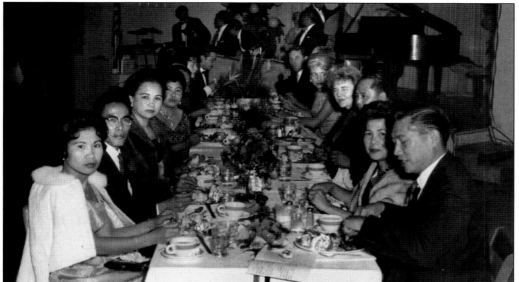

The Officers Club at Fort MacArthur was the venue for many Filipino community events. Here the United Filipino American Services Organization (UFASO) holds its first installation of officers on October 11, 1963. UFASO encompassed all families that were related to the military regardless of the branch of service. (Courtesy of Apostol Family Collection.)

In the December 13, 1969, yearbook of the Filipino Community Center of L.A. Harbor Area celebrating the 20th anniversary of the group, this page appeared listing their debutants of 1969 and the Fil-Am Teen Club. Almost all were born in America. (Courtesy of Marcelino Ines Jr. Collection.)

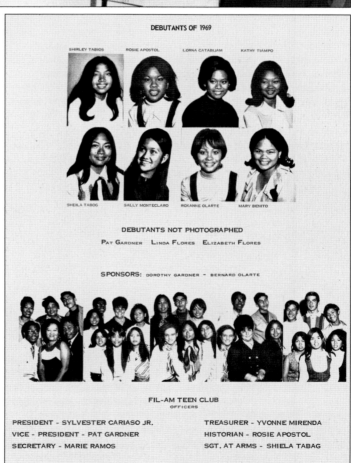

DEBUTANTS OF 1969

SHIRLEY TABIOS ROSIE APOSTOL LORNA CATABIJAM KATHY TIAMPO

SHEILA TABOG SALLY MONTECLARO ROXANNE OLARTE MARY BENITO

DEBUTANTS NOT PHOTOGRAPHED

PAT GARDNER LINDA FLORES ELIZABETH FLORES

SPONSORS: DOROTHY GARDNER - BERNARD OLARTE

FIL-AM TEEN CLUB
OFFICERS

PRESIDENT - SYLVESTER CARIASO JR. TREASURER - YVONNE MIRENDA
VICE - PRESIDENT - PAT GARDNER HISTORIAN - ROSIE APOSTOL
SECRETARY - MARIE RAMOS SGT. AT ARMS - SHIELA TABAG

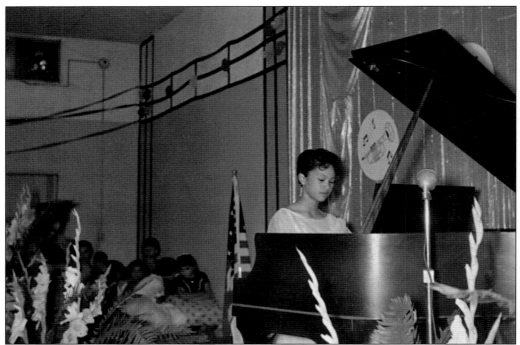

A piano seemed to be a standard feature in many Filipino homes. Children's weekly piano lessons and yearly recitals always seemed to take away from playtime. Francine Inez (above) is playing her memorized recital piece at the Gardena Community Center. Many South Bay area students (below) took their piano lessons from Violeta Reyes. And in some cases, her early students had their own children continue to take lessons from her. In the photograph below, from left to right, are unidentified, Val Reyes, Liling Ines (standing), Violeta Reyes, unidentified child, unidentified (standing), and Valerie Reyes. (Courtesy of Marcelino Ines Jr. Collection.)

The United Filipino American Services Organization hosted an annual Christmas party at Fort MacArthur. It included a children's talent show and a visit from Santa. (Both courtesy of Apostol Family Collection.)

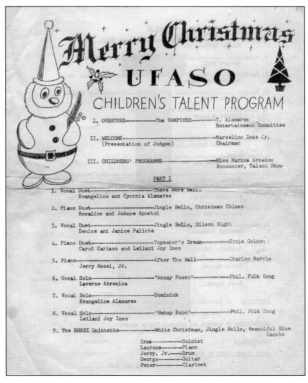

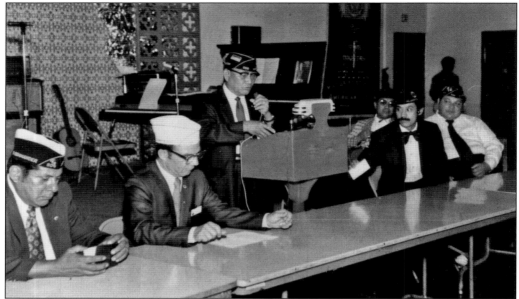

Members of the American Legion, Mayon Post No. 688, attend a meeting held at the Filipino Community Center of Los Angeles Harbor Area. Joe Palicte is sitting second from the right. The center served as a common meeting venue for many local organizations. (Courtesy of Shades of L.A. Archives/Los Angeles Public Library.)

The Orange Relation band grew out of the whole popular music movement of the 1960s and 1970s. Many so-called garage bands sprang up and duplicated what they heard on their popular small Japanese transistor radios. They played for high school dances and Filipino community events. Shown from left to right are Florante Ibanez, Jerry Rossi Jr., Brian Kelly, and George Rossi. Originally the Orange Relation started out as a Rossi family band with Irma Rossi on drums and Laurene Rossi on accordion. (Courtesy of George Rossi.)

Dr. Jenny Batongmalague (in Tagalog, "big rock") is well known locally for her public service. She instigated two free Filipino Harbor Area Health and Community Services Days in 1972 and 1973. They were sponsored by the Filipino Community Center of LA Harbor Area but held at the Wilmington Recreation Center (Wil-Hall) and Park on Neptune Avenue. It was one of the first times these types of large community events had been organized for Filipinos in Los Angeles. (Courtesy of Visual Communications.)

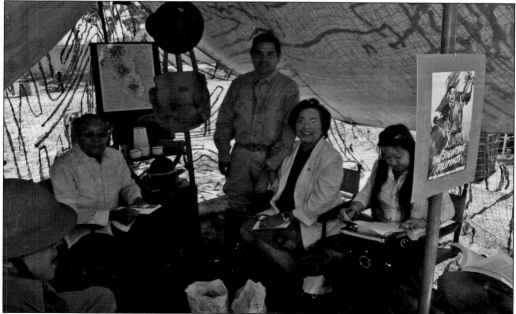

Today Dr. Jenny, as she prefers to be called, continues her community activism with the issue of equity rights for the World War II Filipino veterans. Here she (second from the right) talks about the issue with Joe Nazareno (second from the left) during the 2008 Philippine Independence Day Celebration in Carson's Veteran's Park.

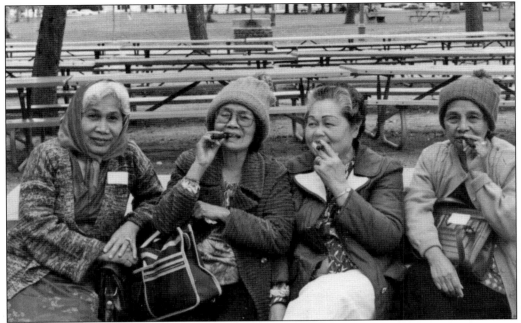

These *Lolas* (grandmothers) take a cigar smoking break during a first birthday party at Banning Park in Wilmington for Gabriela Estepa Ibanez on March 1, 1980. Second from the right is the celebrant's great-grandmother, Amalia Ines Imperio. Pictured (below) at the party are, from left to right, Rosario Adan Estepa (grandmother), Gabriela Estepa Ibanez, Amalia Ines Imperio (great-grandmother), and Laura Ines Rossi (grandmother).

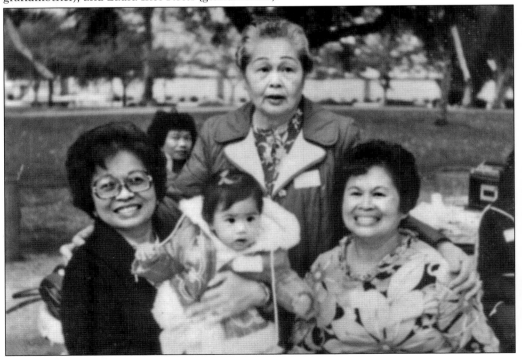

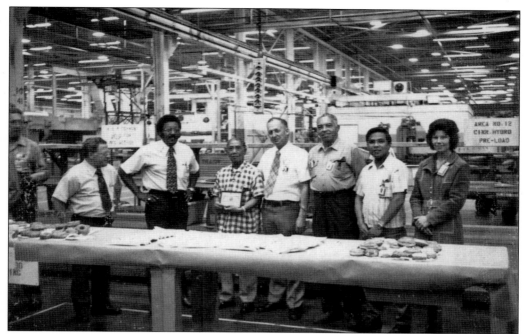

After over 35 years working for the McDonald-Douglas Aircraft Company, Cleto Yabes Ibanez gets his retirement certificate and pin. Many Filipinos entered the South Bay aircraft and aerospace industry, which offered good pay and benefits, in the 1950s and 1960s. Besides Douglas, they also worked for companies like North American Rockwell and Hughes Aircraft. He was a member of the Machinists Union (AFL/CIO) and worked hard for a good retirement pension. He moved to Carson in 1969 from Los Angeles and provided a home for his son, Florante, and his new family.

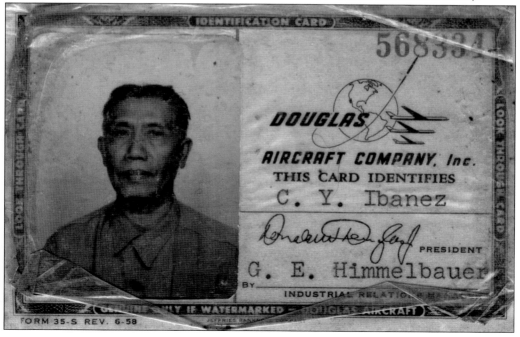

Search to Involve Pilipinos (SIPA) had its start in 1970. During its first weekend gathering of Filipino American youth at Camp Oak Grove, Royal Morales (far right) recruited these South Bay teens. From left to right, they are Sylvester Cariaso Jr., George Rossi, Ana Cariaso (mother of Sylvester Jr. and Carol), Carol Cariaso, Jerry Rossi Jr., Laurene Rossi, and Royal Morales. For most of them, this was the first time youth from the South Bay (American born) met their teen counterparts (born in the Philippines) from the downtown Temple Street area. It was the beginning of a Filipino American identity movement in Los Angeles. In the photograph below, taken at SIPA Camp Oak Grove, are, from left to right, (first row) Jeanne Abella, Eva Gazman, Elsie Dela Cruz, Lillian Tamoria, Clarence ?, and unidentified. All the others are also unidentified.

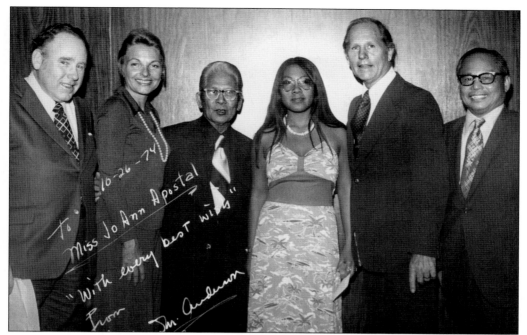

Jo Ann Apostol (third from the right) received congratulations from Congressman Glenn Anderson (second from the right) on October 26, 1974, for being awarded the United Filipino American Service Organization's (UFASO) scholarship. (Courtesy of Apostol Family Collection.)

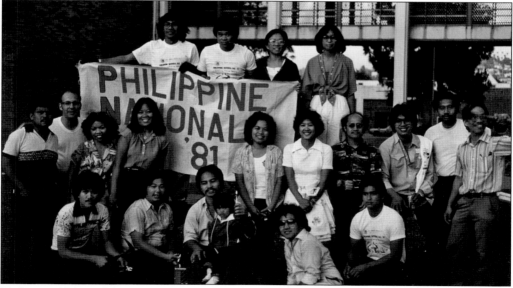

Philippine National Day in 1981 was celebrated by South Bay and Los Angeles college students as part of their West Coast Confederation of Pilipino Students (WCCPS) activities. The WCCPS began as a resolution for the Filipino People's Far West Convention–Student Workshop. It included campuses from Washington state to San Diego. They promoted student activism for admissions and Filipino American classes and professors as well as learning more about the politics in the Philippines under the Marcos dictatorship and involvement in their local communities.

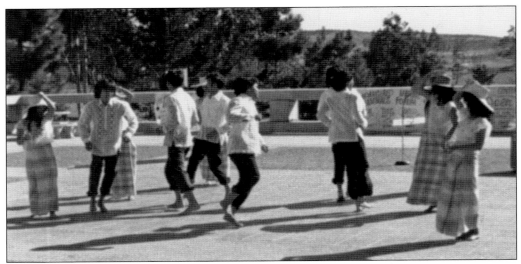

Many student organizations, such as UC Irvine's Kababayan, formed in the 1970s as a reaction to the surrounding social movements for civil rights, social justice, and peace. Above, students from UC Irvine Kababayan and Cal State University Long Beach PAC perform traditional Philippine folk dances during the first Pilipino Day Celebration at UC Irvine in 1975. Since most of the Kababayan members were women, male partners from PAC were recruited for the dances. Some of the Kababayan women to participate were Nora Custodio (far left), Enrie Samano (far right), and Ellie Eugenios Ilagan (second from right).

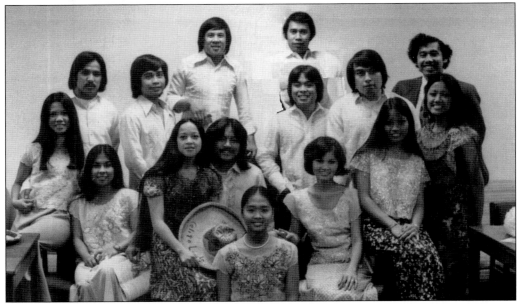

Here Cal State University-Long Beach Pilipino American Coalition (PAC) members performed folk dances at the Downey Civic Center Theater in 1974. They are, from left to right, (center kneeling) Lucinda Custodio; (first row) Linda Palomo, Elvie Caburian, Tricia Espina, Alex Blanco, Vangie Rivera, Tiny Couglan, and Olivia Soriano; (second row) Mike Dagampat, Orly Clores, unidentified, Bob Couglan, and James Constantino; (third row) Ban Montoya and Noe Pabalinas. (Courtesy of Mike Dagampat.)

At Cal State University Dominguez Hills, Pilipino Educational and Cultural Experience (PEACE) formed later than some of the other campuses. Shown here is one of the many activities PEACE hosted. Kneeling in the foreground is Andrew Guerrero, who was one of the principal leaders of the organization. (Courtesy of Andrew Guerrero.)

Minda Sanchez is not only a 1990s alumna of Cal State University Dominguez Hills, she also served as their multicultural center's coordinator in 2001. Here she is pictured with the current multicultural coordinator, Lui Amador. (Courtesy of Alison De La Cruz.)

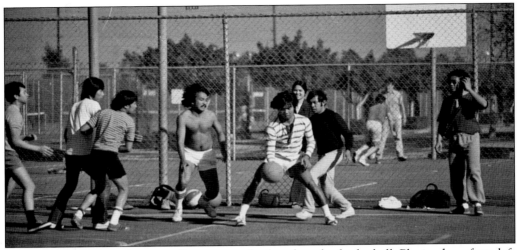

Filipino American students on all campuses also loved to play basketball. Playing here from left to right are two unidentified players, Ban Montoya, Mike Dagampat, Henry ?, Noe Pabalinas, and an unidentified player. Spectator Marsha Hechanova is viewing the action from the fence. (Courtesy of Mike Dagampat.)

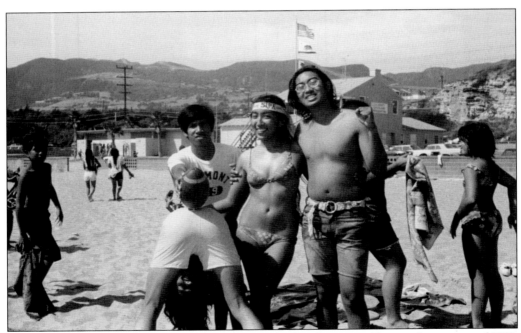

Being so close to the local beaches made it easy to plan beach outings. During the summer of 1972, Ester Soriano and Florante Ibanez (center, leaning together) had jobs as site supervisors for the Summer Neighbor Youth Corp (NYC) programs in Los Angeles and in Wilmington, specifically working with Filipino American youth. This Redondo Beach NYC picnic provided a break from their summer of community work. (Courtesy of Visual Communications Photographic Collections.)

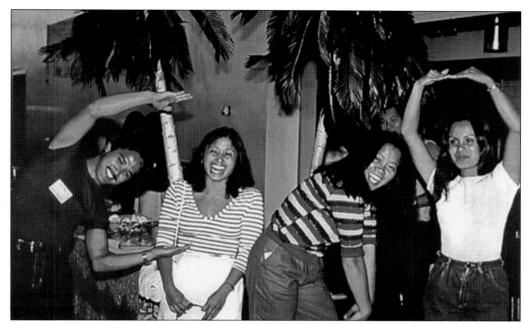

South Bay youth and friends here attended a Filipino immigrant rights conference and decided to try to spell out FIRO for the newly formed group, Filipino Immigrant Rights Organization, in the late 1970s. From left to right, they are Jaime Geaga, Denise Palicte Academia, Rose Ibanez, and Araceli Rufo Rossi.

Part of the campaign to expose the community to the plight of political prisoners under the Marcos dictatorship of the 1970s–1980s was Christmas caroling at homes and collecting donations to help the prisoners in the Philippines. Here are carolers from the Coalition Against the Marcos Dictatorship (CAMD): from left to right, Jerry Espejo, Jaime Geaga, Sal Morano, and Carol Ojeda-Kimbrough.

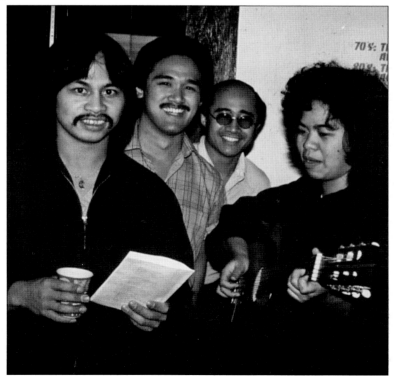

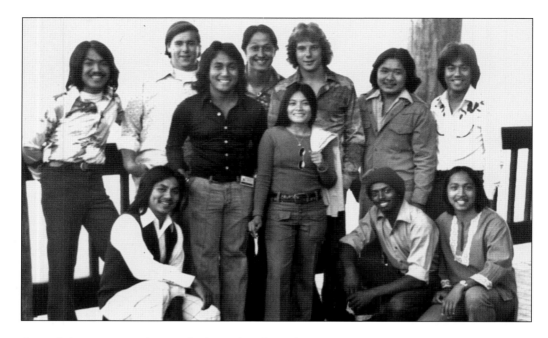

One of the most popular youth dance bands in the 1970s was BARKADA. The group had its beginnings from musicians meeting each other during the early SIPA Camp Oak Grove weekends. BARKADA had a full rhythm and horn section and was constantly in demand for college dances, weddings, and proms. Pictured are BARKADA members with other musician friends. Here is an example of dance tickets and admission costs back in those days. (Courtesy of Royal Morales Collection.)

KDP PRESENTS

KILUSAN I

FUND RAISING DANCE

FEATURING: F M * BARKADA * WINFIELD SUMMIT

**APRIL 20, 1974 8:30 P.M. to 1 A.M.
GARDENA YOUTH CENTER**
1730 W. Gardena Blvd. (cross street Western)
Donation $2 advance; $2.50 door

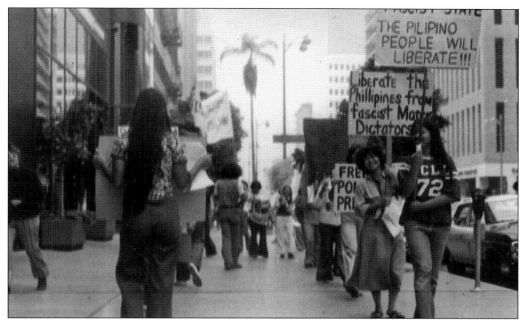

South Bay youth and community activists would also participate in anti-Marcos demonstrations along with others at the Philippine Consulate in downtown Los Angeles. Here they are demonstrating at Wilshire and Rimpau Boulevards, the former location of the consulate. (Courtesy of Royal Morales Collection.)

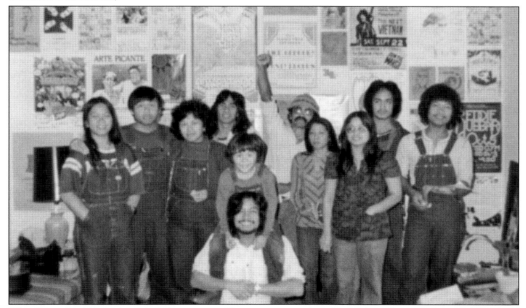

The Union of Democratic Filipinos, or Katipunan ng mga Demokratikong Pilipino (KDP) in Tagalog, was one of the main groups leading the movement against the Marcos dictatorship, but they also organized around social justice issues affecting Filipinos in America as well, such as affirmative action, rights for immigrants, and specific cases of injustice, like the Narciso-Perez case that accused innocent nurses of murdering VA Hospital patients in Ann Arbor, Michigan.

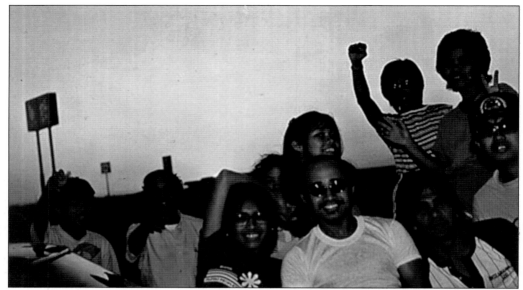

The F/Pilipino People's Far West Conventions (FWC) had their start in Seattle, Washington, in 1971. These gatherings continued annually until 1985 and provided a time for West Coast community activists and students to come learn from each other, compare notes, and plan strategies for their cities and campuses to improve the condition of our collective community. This photograph was taken in 1981 on the carpool road trip to the FWC in Seattle. Among the Los Angeles delegation pictured are, from left to right, Bruce Palicte, Joe Palicte, Maria Abadesco, Minerva Baltazar, Cristina Go, Sal Morano, Maribel Yanto, Ben Yanto, Carol Ojeda-Kimbrough, and Florante Ibanez.

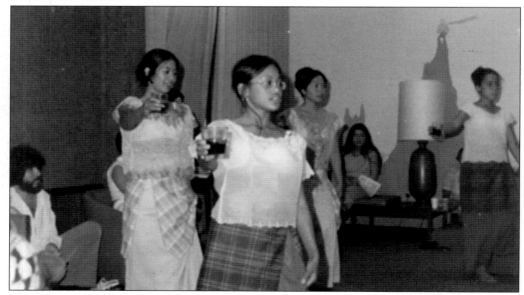

The Pilipino Youth Center (PYC) dancers based out of the Filipino Community Center of LA Harbor Area are seen here performing Philippine folk dances for the summer Educational Opportunity Program (EOP) in the dorms at UC Irvine in 1974. Dancing are, from left to right, Liz Viray, Janice Palicite, Elsie Dela Cruz, and Suzie Magalona.

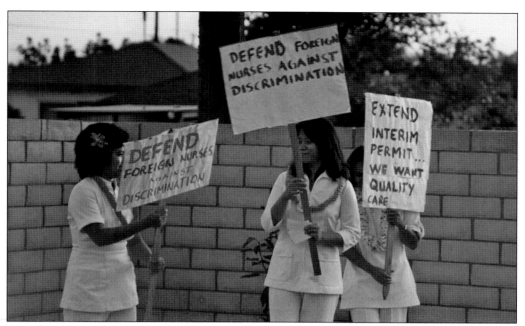

Part of the program for a luau fund-raiser in Carson to help pay for carpool gas to the next FWC included this skit about foreign-trained nurses being deported because of bias found in the nurse licensing exams. The actors are, from left to right, Carol Ojeda-Kimbrough, Rose Ibanez, and Araceli Rossi.

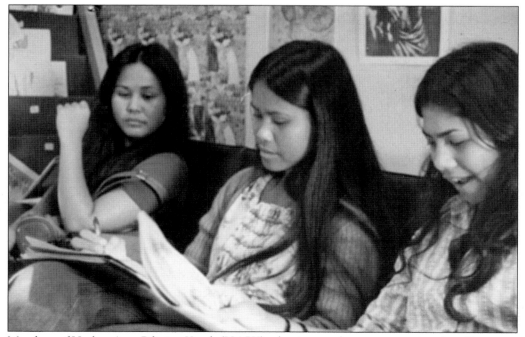

Members of Harbor Area Pilipino Youth (HAPY) take time to plan an event using the office space donated by the Filipino Community Center of LA Harbor Area to the PYC program. The HAPY members are, from left to right, Marie Bacani, Agnes Bacani, and Donna Magalona-Sarjant.

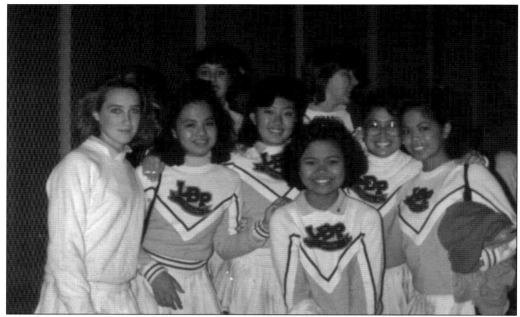

Into the 1980s, students continued to be involved. High school Filipino clubs were formed at Carson High and a few other local schools. Long Beach Poly High School, besides Filipinos being active in cheerleading and the drill team, also had informal Filipino groups off campus. The pictured 1985 Long Beach Polyettes were, from left to right, Patricia Page, Hyung-Ji Choi, Julie Calimquim, Eileen Gerona, and Rachel Dualan. One of the unofficial groups was the Emperial Sisters Social Club (below), comprised of students from Stephens Junior High. The sisters are, from left to right, (seated) Joy Bacamante, Shamaine Almanza, Liza Navarro, Nerissa Colanta, Beverly Fontanares, and Patricia Page; (standing) Rosemary DeGarnz, Vienna Ibanez, Julie Calimquim, unidentified, Monica Barrera, and Charlene Goldfarb. (Both courtesy of Julie Hatch family.)

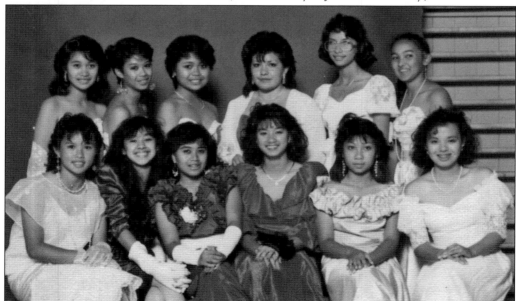

Felipe Lamug Jr. received his first Holy Communion on May 9, 1959, at Mary Star of the Sea Catholic Church in San Pedro. He attended San Pedro High and went on to UCLA, where he became the indispensable teaching assistant to Royal Morales for his Filipino American experience classes. (Courtesy of Felipe Lamug Family Collection.)

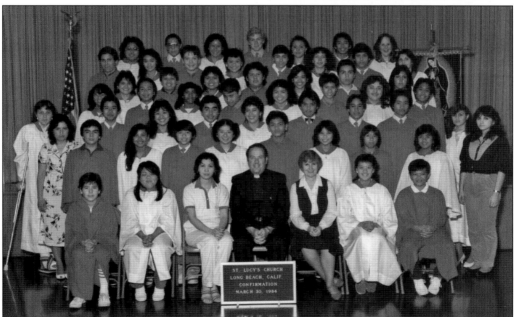

St. Lucy's Catholic Church in West Long Beach has always had a high attendance of local Filipino families. In its confirmation class on March 30, 1984, this was certainly confirmed. Other local churches with large congregations of Filipinos include St. Philomena in Carson and Holy Innocents in Long Beach. (Courtesy of Julie Hatch family.)

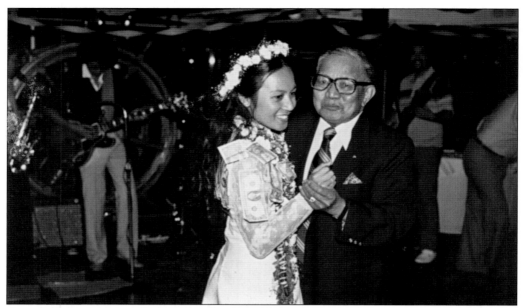

Crispulo Lalata gave away his youngest daughter, Gloria, aboard the SS *Princess Louise* on December 30, 1982, to Tony Shepherd. The ship had been converted into a floating restaurant and moored on Terminal Island. It was a classy place to take a date or host a party, but unfortunately in 1990, she sank and was not salvageable. Crispulo Lalata served as a chief petty officer in the navy, and the family lived in San Pedro across from Fort MacArthur.

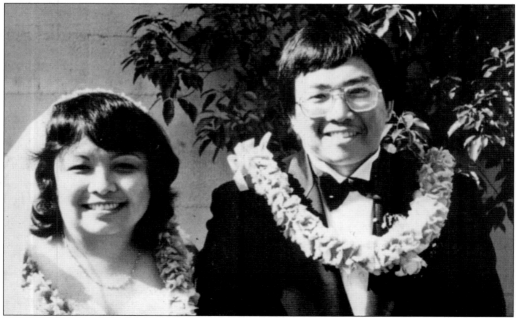

College sweethearts Casimiro Tolentino and Jennifer Masculino tied the knot on June 5, 1982, at St. Philomena Church in Carson. Masculino had attended Banning High School in Wilmington. Together with other Banning alumni Florante Ibanez and Sheila Tabag-Napala, they cofounded the UCLA Samahang Pilipino student organization in 1971.

Four

LOCAL LEGENDS

BOBBY BALCENA, AUNTIE HELEN BROWN, AND UNCLE ROY MORALES

Featured in this chapter are three Filipino American champions from the South Bay area. Each has made great contributions to his or her community as role models and leaders because of their exceptionable lives of giving. Helen Summers Brown, Royal Morales, and Robert Balcena are not the only ones deserving to be recognized, but the authors thought it important to highlight their stories. Unfortunately it was very difficult to find more images of Bobby Balcena to include here, so the authors hope his story can give him the honor he deserves. Somewhat of a rarity in that he threw from the left side but hit from the right, Bobby Balcena was even more unique as the first Asian and first Filipino to ever play in Major League Baseball. Here Uncle Roy stands next to Auntie Helen after she received one of her many community awards. (Courtesy of Royal Morales Collection.)

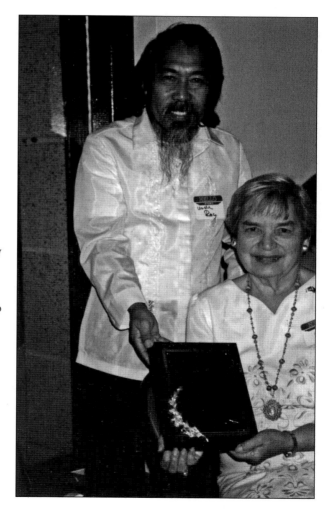

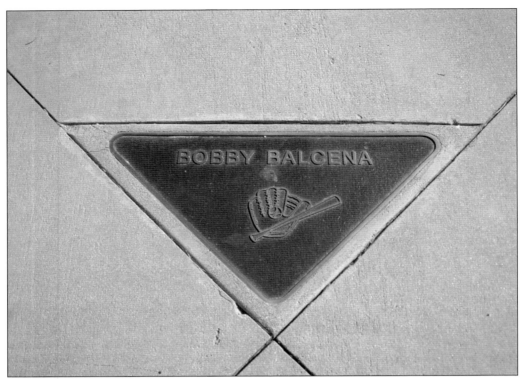

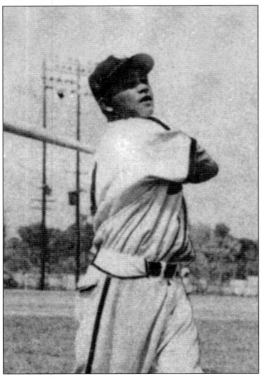

Robert Rudolph Balcena (1925–1990) was born in San Pedro on August 1. On San Pedro's Sixth Street Sportswalk, among the bronze markers of notable names such as Wilt Chamberlin, Don Drysdal, and Traci Austin is the name of Bobby Balcena. His parents were both Philippine immigrants. His father, Fred, came from Iloilo and his mother, Lazara, was from Cavite. Bobby had a brother, Fred Jr., and sister, Florence. He started baseball when he was six and went on to letter in football and track and field at San Pedro High. While a teen, he joined the navy and served during World War II for three years. In 1948, his first year out, he led the Sunset League in hitting at .369 and made the all-star team. In 1949 in the same league, he finished runner-up for the hitting crown with a .367 average with 16 home runs and a .602 slugging percentage and again made the all-stars.

The 5-foot-7-inch, 160-pound Balcena played professional ball in other places, too, such as Mexicali and Buffalo and was a beloved member of the 1955 Seattle Rainiers team that won the Pacific Coast League pennant. In September 1956, he was acquired from the Rainiers by the Cincinnati Redlegs and appeared in seven games. This short period was to be Balcena's only shot at the major leagues. Overall, he appeared in 2,018 games, went to bat 7,141 times, and had 2,019 base hits, including 134 home runs and a career .282 batting average. He retired after the 1962 season at the age of 38 and worked as a longshoreman in both Seattle and his native San Pedro. Bobby died at his home in San Pedro on January 5, 1990. (Courtesy of the Filipino American National History Society (FANHS.)

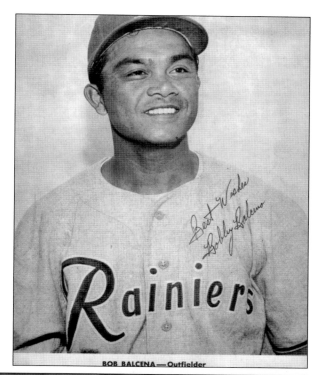

BOB BALCENA—Outfielder

Following in Balcena's family footsteps is Jodie Ellen Legaspi. Bobby's brother-in-law, Alex Legaspi, became a well-known adult fast-pitch softball player and trained two sons, Jimmy and John, to be baseball stars at Banning High in Wilmington. John Legaspi, a lefty first baseman and outfielder, married Nora Figueroa, a swimmer, and Jodie was born. The No. 12 on Jodie Legaspi's championship UCLA Bruins shortstop uniform was her tribute to her great-uncle Bobby. A four-time All-Pac 10 selection, Legaspi also garnered 2006 Easton All-American recognition. She currently plays professional softball on the Professional Fastpitch Xtreme Tour and is an assistant coach at Cal State University Chino. (Courtesy of the Legaspi family.)

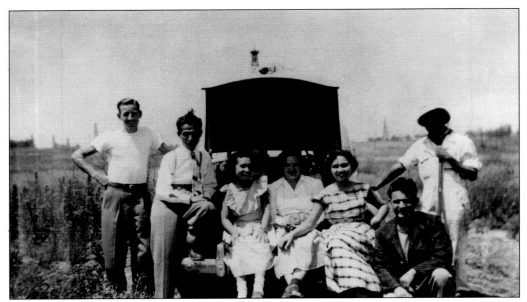

In 1985, the Filipino American Library (FAL) was founded by longtime Hermosa Beach resident Helen Agcaoili Summers Brown (1915–). It was largely collected from her father's personal library, accumulated while he served as one of the first American colonial teachers sent to the Philippines. Auntie Helen, as she is popularly known in the community, originally established it as the Philippine American Reading Room and Library (PARRAL). Above is a family outing on a Lomita farm. Rosie Agcaoili is seated second from right, and Helen Brown is next to her (third from right). (Courtesy of Shades of L.A. Archives/Los Angeles Public Library.)

Although born and raised in Manila, Auntie Helen moved with her family to America, attended Pasadena Junior College, and graduated from UCLA with her baccalaureate and master's degrees both in education in 1937. It is believed that she may have been the first Filipina to graduate from UCLA. (Courtesy of Helen Brown Family Collection.)

While at UCLA, she met her sweetheart, William Brown. They later wed, but because of the anti-miscegenation laws banning whites from marrying non-whites, they had to get married in Boulder, Nevada. (Courtesy of Shades of L.A. Archives/ Los Angeles Public Library.)

Here the Brown family enjoys a meal at Clifton's Cafeteria in 1951. From left to right are Billy Jr., Michael, Helen, George, Jimmy, and William Brown. (Courtesy of Shades of L.A. Archives/ Los Angeles Public Library.)

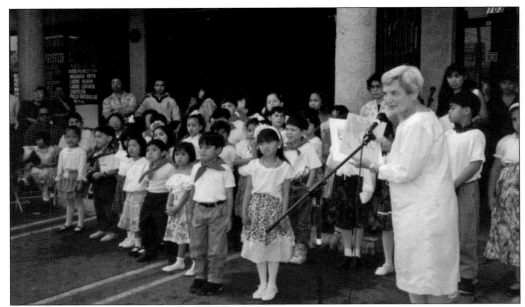

Brown worked as a teacher and counselor for the Los Angeles Unified School District where she discovered the difficulties of most Filipino American students and even teachers in accessing resources and materials on the Philippines. She advocated to the school district to recognize the needs of these children and fought for bilingual education and retention and the promotion of minority teachers.

Members of the Filipino American Library, relatives, and friends gather for Helen Brown's 91st birthday in 2007 at her Sunrise Assisted Living Residence in Hermosa Beach, close to her sons. A short documentary on her life was done by Florante Ibanez in 2006, *Got Book?: Auntie Helen's Gift of Books*. (Courtesy of Filipino American Library Collection.)

Helen Brown officially retired from the FAL board in 1999 and has received numerous awards for her community work. Here she is being presented at city hall by then Los Angeles councilwoman Jackie Goldberg.

Here Helen is shown attending one of the annual Filipino American Library Gala Benefits held at the Millennium Biltmore Hotel and being honored along with her family. (Courtesy of Ned Vizmanos.)

Royal Frank Layus Morales (1932–2001), affectionately known by the Filipino American community and his many students as "Uncle Roy," was born in 1932 on Bunker Hill, Los Angeles, and passed on at his Gardena home in 2001. After growing up in Ilocos Norte, Philippines, he moved to Hawaii and later Los Angeles, where he attended Chapman College and later earned a master's degree in social work from USC. (Courtesy of Shades of L.A. Archives/Los Angeles Public Library.)

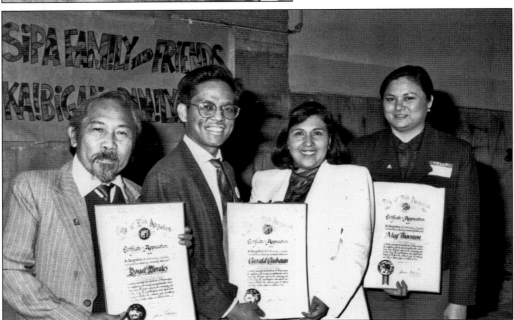

Royal Morales receives recognition from county supervisor Gloria Molina for his community service with Search to Involve Pilipino Americans (SIPA) and others. They are, from left to right, Royal Morales, Gerald Gubatan, Gloria Molina, and Meg Malpaya Thornton. (Courtesy of Royal Morales Collection.)

Morales served as program director of the Pacific Asian Alcohol Program and was director of the Asian American Community Mental Health Training Center of Los Angeles. Above, Uncle Roy conducted P-Town Tours with his UCLA class students to convey the sense of place and history to them of what is now designated as Historic Filipinotown. Uncle Roy (below) was always there to support Asian/Pacific Islander community events. Here he identifies the secret ingredient of the SIPA entry to the Visual Communications Chili Cook-off Fund-raiser. (Both courtesy of Royal Morales Collection.)

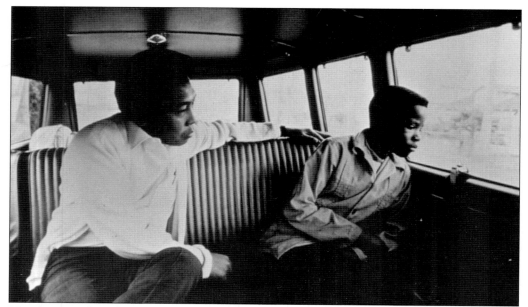

Morales served in the army during the 1950s and served as a counselor. Afterward, he then devoted much of his career to assisting troubled youngsters in Los Angeles. In the 1970s, Uncle Roy cofounded Search to Involve Pilipinos (SIPA) out of concern over problems among the increasing numbers of Filipino youths here. The USC Asian Pacific American Support Group honored him for that work in 1986. (Courtesy of Royal Morales Collection.)

He also authored *Makibaka: The Pilipino American Struggle* in 1972 and followed it with *Makibaka 2* in 1998. He taught the popular Filipino American Experience class at UCLA for over two decades. In Morales's honor, the university established the Royal Morales Prize in Pilipino American Studies, an annual award for the most outstanding undergraduate paper on the subject. "He has influenced literally thousands of Filipino American students. . . . He is a national living treasure," said Don Nakanishi, director of the UCLA Asian American Studies Center, at Morales's retirement. (Courtesy of Royal Morales Collection.)

Here he attends another community event at the Los Angeles Theater Center. From left to right are Candy Mendoza, Al Mendoza, Royal Morales, and Ester Soriano. Both Al Mendoza and Ester Soriano were early organizers of SIPA along with Uncle Roy.

As a pillar for the Filipino Christian Church, he secured its recognition as a California Historical Site. Uncle Roy was an influential community organizer and popular speaker on the Filipino Americans, Philippine-United States relations and history, and dealing with alcohol abuse. Over the years, he kept strong contacts with the Philippines, traveling there annually to aid a high school his parents helped to establish.

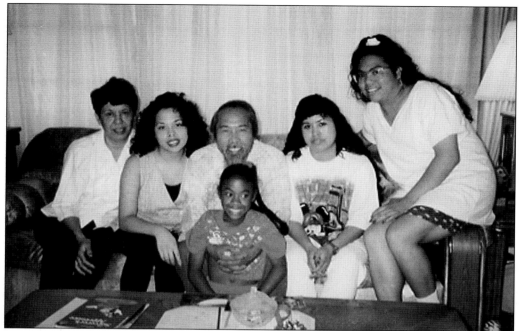

In 2009, Roy's wife, Annabelle, and daughters, Faith, Victoria, and Kathy, donated his archival collection to the Library of Congress. Captured in the family photograph above are, from left to right, Annabelle, Victoria, Royal, granddaughter Ranika (below), Kathy, and Faith.

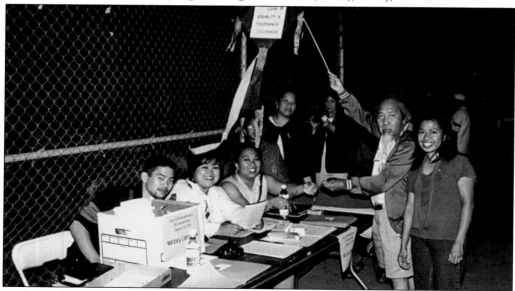

Uncle Roy played an active role in organizing when Joseph Ileto, a Filipino American postal worker, was gunned down in a 1999 hate crime incident. Here he is holding a kite at the registration for the Ileto Belmont High Rally featuring then U.S. attorney general Janet Reno. From left to right, they are Ryan Yokota, Gigi Santos, Teresa Valente, Gabriela Ibanez (under tail of kite), Roselyn Ibanez, unidentified, Royal Morales, and Lulu Amador. Uncle Roy was also known for his Philippine kite and parrol (Philippine Christmas lantern) making classes for youth.

Five

ARTS AND CULTURES
FROM THE ROCKY FELLERS TO
FESTIVALS AND HIP-HOP

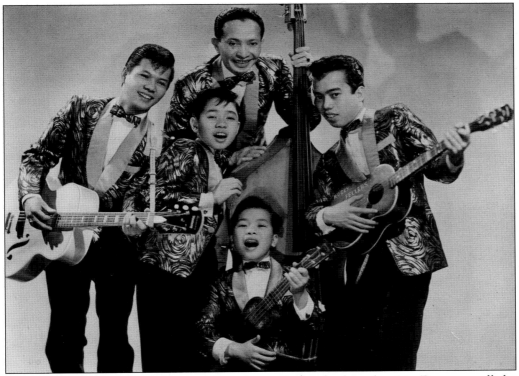

It is said that Filipinos love to entertain and are gifted and talented artists. Do you recall the *Ed Sullivan Show* and watching the Filipino boy band called the Rocky Fellers? In the early 1960s, they were viewed by millions on television when they made the rounds to other popular programs, including the *Jack Benny Program*, *Dinah Shore Show*, and *Jackie Gleason Show*. The City of Carson also recognizes its Filipino American residents by promoting the annual June 12 Philippine Independence Celebration at Veterans Park. In San Pedro, one of the largest Filipino community events in the country occurs every September, the Festival of Philippine Arts and Culture (FPAC) produced by FilAm ARTS. In addition to the traditional dance, visual, and musical arts, Philippine martial arts has a longtime home in Carson as well. Local youth have adopted and incorporated hip-hop and spoken word into their own Filipino American lifestyles. (Courtesy of Maligmat Family Collection.)

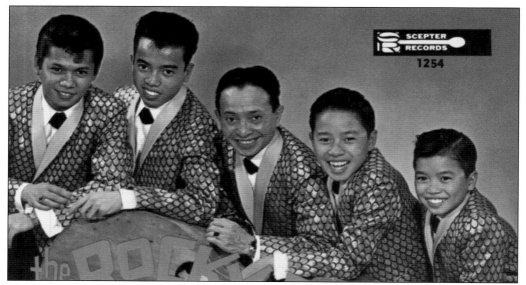

The Rocky Fellers was comprised of the Maligmat family's four brothers and their father as seen on their album cover: from left to right, Junior, Tony, father Doroteo "Moro" Maligmat, Albert, and Eddie. They were a family band long before the Jackson 5 and the Osmonds. Their top single hit, "Killer Joe," reached the number 16 spot on the Billboard Top 100 in April 1963. Besides the boys, there were also mom and the Maligmat sisters. Here the family is gathered for Eydie's, the youngest, christening in 1963. The girls from left to right are Virginia, Rocky, Yolanda, Zenaida and mother Concepcion holding Eydie. The eldest sister, Estella (not shown), remained in the Philippines when the family moved to the United States. Albert later went on to play with the popular Society of Seven (SOS) in Hawaii, and Eddie played with famous Hawaiian entertainer Don Ho. Although all members of the Maligmat family have moved across America, they still have their family home in Carson. (Both courtesy of Maligmat Family Collection.)

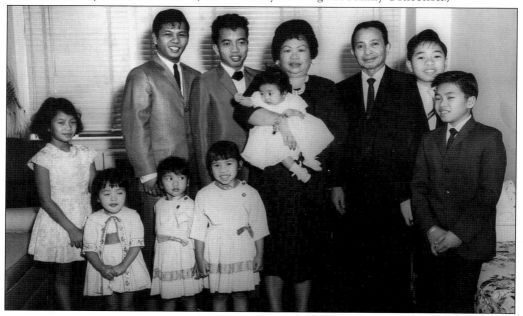

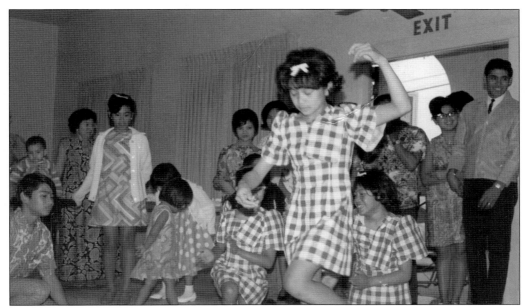

Although they only knew the Tinikling and a few other folk dances, these young dancers from Wilmington performed for many audiences back in the 1960s. From left to right, they are George Rossi (kneeling), Leilani Ines, Laurene Rossi, and Irma Rossi. (Courtesy of Laurene Rossi Hallman.)

Eliseo Art Silva, a widely recognized Filipino American artist, was commissioned in 1996 by the City of Carson to produce this mural depicting the history and diversity of the city. It is titled *Roots and Wings* and was located on the south exterior wall of the Manila Business Center in Carson. On April 4, 2009, the mural was restored and redesigned with graffiti-resistant materials by the artist and local students. In 1995, Silva also was curator of the contemporary Filipino American art exhibit Tastes Like Chicken at California State University, Dominguez Hills. (Courtesy of Royal Morales Collection.)

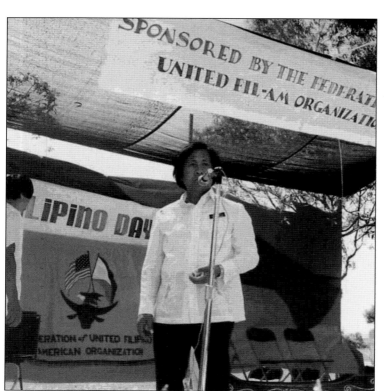

Ralph Quinte, president of the Federation of United Filipino Organizations, spoke to the audience during the Filipino Day festivities on June 12, 1977, to commemorate Philippine Independence Day. The day included a program and motorcade from Carson City Hall along Avalon Boulevard to the Wilmington Recreation Center (Wil-Hall) and Park on Neptune Avenue. Julie Valde (below) was the lucky youth selected to ride the lead car during the June 12, 1977, motorcade. (Both courtesy of Marcelino Ines Jr.)

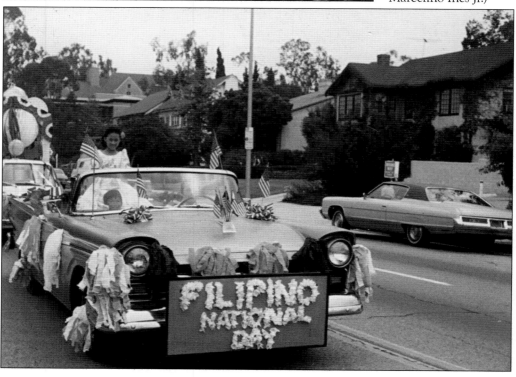

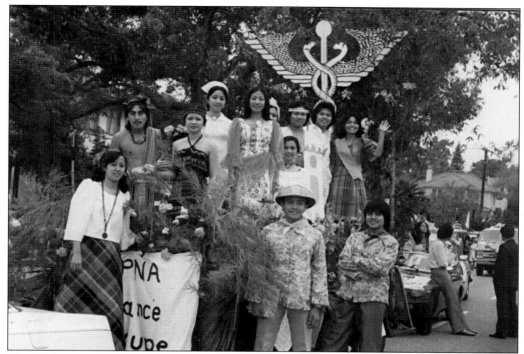

The Philippines Nurses Association Dance Troupe above prepares to perform for the June 12 event in Wilmington before joining the motorcade parade down Avalon Boulevard.

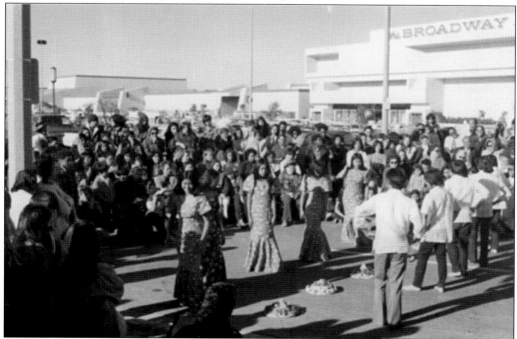

This young and talented group performed in front of Carson's South Bay Pavilion in the 1970s and attracted a crowd away from the mall. (Courtesy of Marcelino Ines Jr.)

Helen Summers Brown (left) is shown here with other members who started the Filipino American Library. PAMANA was the name of the original nonprofit foundation created in order to apply for funding grants. The members present from left to right are Helen Summers Brown, two unidentified women, Tania Azores, and Victor Genrano. Genrano was also the publisher and editor of *Heritage Magazine*, produced in Carson from 1987 to 1999. It was the "Magazine of Filipino Culture, Arts and Letters and the Filipino American Experience." (Courtesy of Royal Morales Collection.)

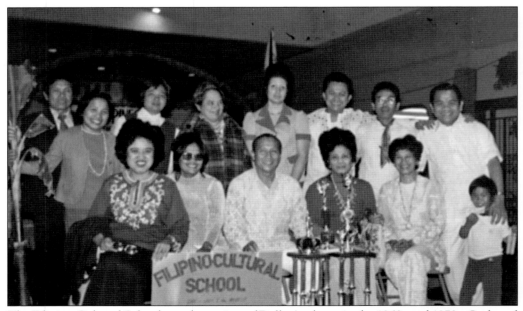

The Filipino Cultural School was the project of Dolly Anthony in the 1960s and 1970s. Gathered here are from left to right are (seated) Dolly Anthony, unidentified, Frank Garovillo, ? Garovillo, Mercedes Patano, and unidentified child; (standing) five unidentified guests, Dr. Richard Garovillo, Marcelino Ines Jr., and Roman Patano. (Courtesy of Marcelino Ines Jr.)

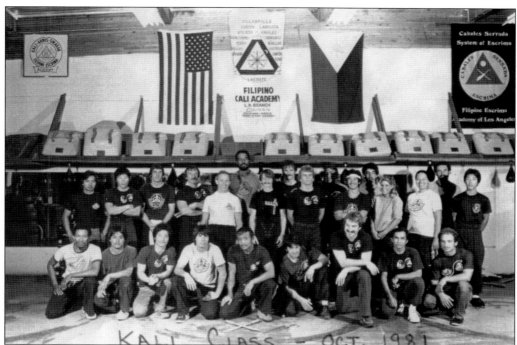

In 1974, Sifu/Guro (master teacher) Dan Inosanto and Sifu/Guro Richard Bustillo founded the Filipino Kali Academy at 23018 South Normandie Avenue in Torrance. Since then, the group has moved locations and reorganized into the International Martial Arts and Boxing Academy, Inc. (IMB), located on Vermont Avenue in Carson. Inosanto and Bustillo were both students and close friends of Bruce Lee and are recognized for revitalizing the martial art of Filipino stick fighting, also known as Eskrima and Arnis. This photograph was taken in October 1981. Below is the first page of a comic book–style history of *The Revival of KALI*, as told to Sal Morano and Rod Benitez by Dan Inosanto and Richard Bustillo. Sal Morano grew up in Wilmington and was also a writer of other styles and today is a librarian. (Both courtesy of IMB.)

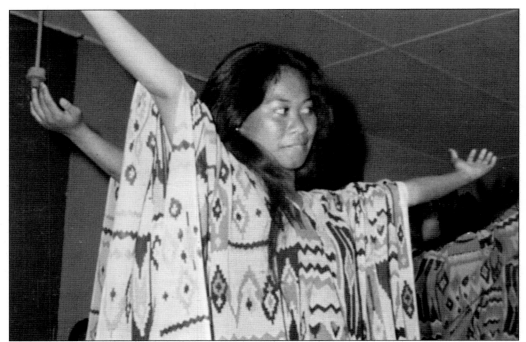

Performed here is the Makibaka Dance, created by Liz Viray Dacut as a modern expressionist dance set to the music of the song "Makibaka" by Dakila, a San Francisco–based Filipino Latin rock soul band. It became popular and was performed at conferences and cultural events beyond Los Angeles. Carson youth Janette Fronda performs above.

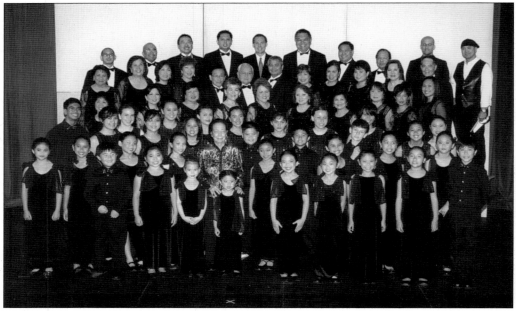

The Filipinas Chorale USA and the Cherubs are led by Sr. Marie Vincent Llamzon and shown here performing for their summer concert in June 2008 at the Cal State University Dominguez Hills Theatre. (Courtesy of Marcelino Ines Jr.)

92

From left to right, Dom Magwili, Bruce Locke, and Eric Ines hang out at Dragon Fest 2002, a showcase autograph fair for martial artists and other related celebrities. Magwili is a seasoned Filipino American actor with many credits. In the past, he has volunteered his expertise to help in the productions of the annual Pilipino Cultural Nights (PCN) at local college campuses. Recently he has taken up teaching students at Cal State University Long Beach.

This play production based on the Carlos Bulosan semi-biographical novel *America Is in the Heart* was performed at Cal State University Dominguez Hills in the 1990s. The book is routinely assigned for Asian American and Filipino American studies classes. Instrumental in this production was Carson resident and journalist Fe Koons.

A large class of incoming Filipino American librarian students at UCLA was treated to lunch by veteran UCLA librarian Eloisa Gomez Borah in spring 2004. Borah is also an avid historian and researcher of Filipino American history. A Long Beach resident, her history Web site on the subject gets many hits a day that go far beyond the boundaries of the city.

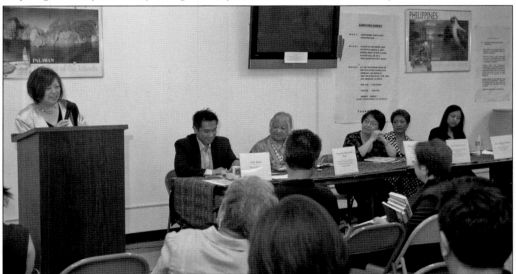

Linda Nietes (far left) and her Philippines Expression Bookshop have been supplying books for the Filipino American community for years. Although she no longer has a storefront, she has used festival and conference space to display and sell her books. She also operates her book mail order business from her home in Rancho Palos Verdes. Here she addresses the audience at the Los Angeles Philippine Consulate during the Authors Night that she regularly hosts to expose new books. Her Philippine Expressions booth is a regular participant in the L.A. Times Festival of Books at UCLA.

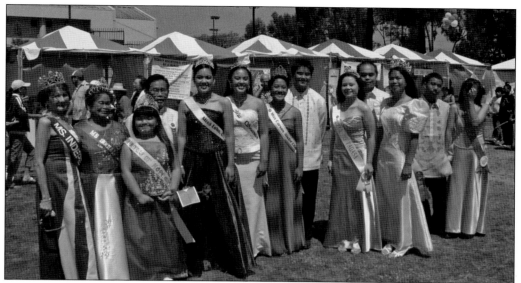

Beauty pageants and queen contests have seemed to be a recurring blessing and obstacle to the Filipino community. In the past days of social box dances, they were used as fund-raisers for organization building and later had the stigma that whoever could buy the most tickets for a candidate would be declared the winner. As the women's movement arose, so did criticism of Filipinas being objectified and not recognized for their skills and intellect. Today most would agree that Filipino American women are equal members of the community and queen contests can still have their place to recognize a woman's inner and outer beauty. The queens above participated in the 2008 Carson June 12 Independence Day celebration at Veterans Park. Below, young Rondalla musicians show off their skills during a past Carson June 12 event. (Below courtesy of Carson mayor Jim Dear.)

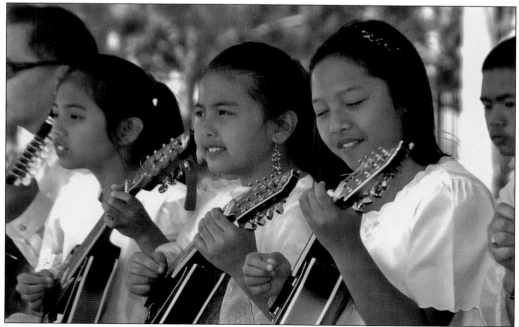

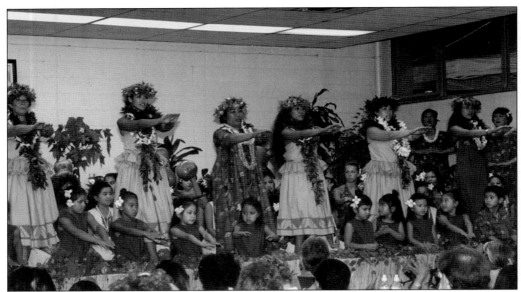

With a close affinity to Pacific Islanders in Carson and the South Bay, many Filipino families have enrolled their children to learn Hawaiian hula, perhaps even more so than to learn Philippine folk dancing. Pictured here is Hula Halau 'O Lilinoe of Carson led by Kumu Auntie Sissy Kaio (third from left). She estimates that about 70 percent of the over 100 members are Filipino Americans. The popular group was also featured in the PBS documentary *American Aloha: Hula Beyond Hawai'i*.

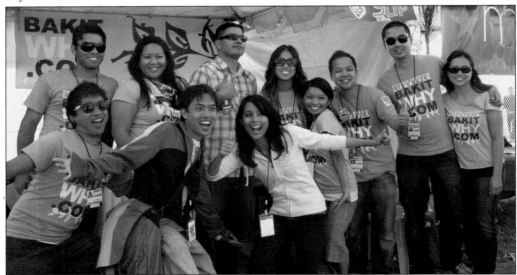

Among more high-tech ways to promoting and connecting Filipino American culture and experience beyond Facebook and YouTube, there is BakitWhy.com. Here they are with Internet celebrity Happy Slip during the 2008 Festival of Philippine Arts and Culture (FPAC) held in San Pedro at Point Fermin Park. Many of the team hail from the South Bay; from left to right, they are Justin Madriaga, Ahmad Shiraz, Kathlyn Amidar, Leo Gali, Richard Frias (Happy Slip's manager), Christine Gambito (Happy Slip), Laureen Abustan, Rachel Wagoner, Jeremiah Abraham, Kaywan Shiraz, and Christianne Macaraeg.

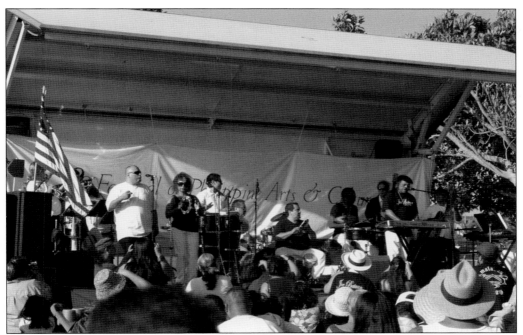

The Festival of Philippine Arts and Culture (FPAC) has become an institution in Southern California for the top entertainment and cultural authenticity produced during the annual weekend event. Although it had its beginning at Los Angeles City College, it has gained a very appreciative 30,000-plus audience at San Pedro's Cabrillo Beach and now Point Fermin Park. Above, Latin jazz rock soul performer Joe Bataan (playing keyboard) has appeared on stage and drew record crowds. Below are Kiwi and Bamboo separate and together as Native Guns brought rap and hip-hop home to the festival for a number of years.

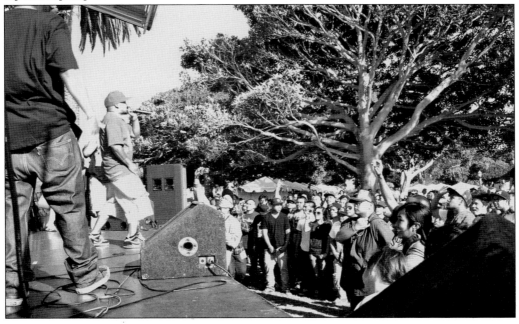

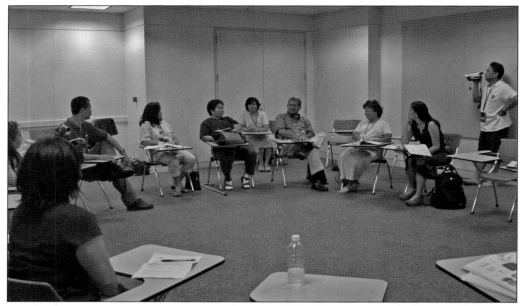

Loyola Marymount University was the site of the 2002 Filipino American National Historical Society (FANHS) Conference and included this "Harbor Area and the Flip Hall" round table session. Participants included, from left to right, Teresa Valente, unidentified, Felipe Lamug, Rose Ibanez, Caron Ojeda-Kimbrough, Darlene Ventura, Bob San Jose, Janet San Jose, unidentified, and Florante Ibanez.

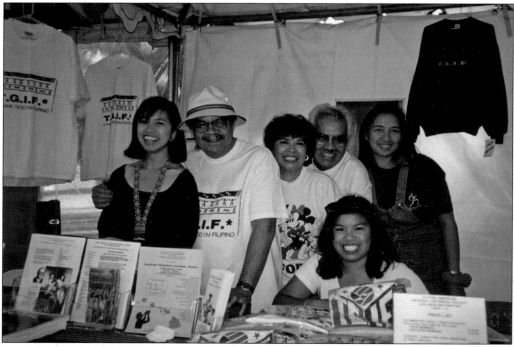

At the Festival of Philippine Arts and Culture (FPAC), the local Los Angeles FANHS chapter usually has a booth with their video, literature, and merchandise for sale.

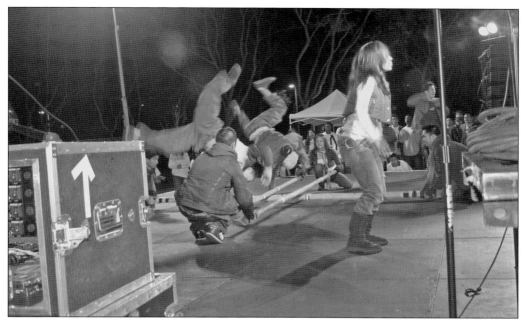

Here at Cal State University Long Beach, the Pilipino American Coalition combines hip-hop with traditional Tinikling dancing for their 2006 annual Christmas Fest. Filipino American college students today have benefited from the early student struggles of the 1970s and now have Filipino American faculty and P/Filipino American studies on their campuses, like Prof. Linda Maram at Long Beach.

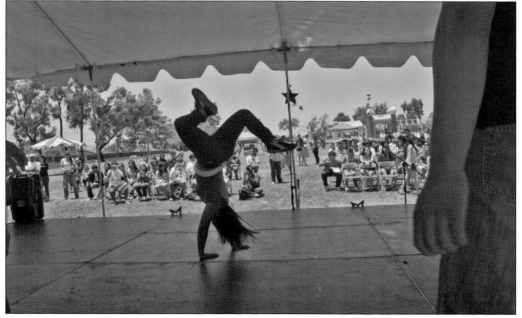

At the June 12 celebration in Carson, youthful dancers, singers, and other entertainers had their own stage area in Veterans Park where they could express themselves. Community leader Jun Aglipay helped to coordinate that space and also acted as master of ceremonies.

Icy Ice (Isacio D) is one of L.A.'s premier deejays. His versatile style of DJing has him playing at the hottest exclusive club venues locally and internationally. He is an original member of the World Famous Beat Junkies since 1992 and has performed in countries such as Japan, Canada, Mexico, Philippines, Europe, and Australia. Icy Ice is also a veteran on the L.A. radio airwaves currently mixing for the *Rick Dees Morning Show* on Movin 93.9 FM as well as 90.7 KPFK Divine Forces Radio every Friday night and can also be heard on over 300 stations nationally syndicated through the Superadio Network. Icy Ice is from Carson and graduated from Cal State University Dominguez Hills. He owns his own online business, Stacks Vinyl. (Courtesy of Icy Ice.)

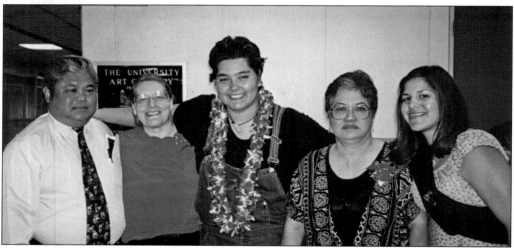

Alison M. De La Cruz from Carson is an artist, cultural activist, and ate (older sister). De La Cruz is the writer, narrator, and associate producer of *Grassroots Rising*, a documentary exploring the experiences of low-wage Asian immigrant working families in Los Angeles. As part of the project, De La Cruz was a California Arts Council Artist in Residence with Visual Communications and taught writing workshops at the Pilipino Workers Center. She has also taught writing and theater workshops throughout Los Angeles with organizations such as Asian Pacific Islanders for Reproductive Health–HOPE Project, Great Leap, Inc., HeART Project, and for Eskuwela Kultura, a program of FilAm ARTS. De La Cruz was recently the playwright and facilitation director working with Shakespeare Festival/LA's Will Power to Youth Program. (Courtesy of Alison De La Cruz.)

Six

AN EMPOWERED
COMMUNITY EMERGES

From the 1980s through today, there has been much political activity and a surge of Filipino Americans running for office, working as political staff, appointed to various commissions, and establishing organizations that focus on political and social issues. For many years since the incorporation of Carson as a city, many Filipinos have run for office but could not gather enough votes to succeed. In 1997, Peter Fajardo was the first Filipino American elected mayor to the city of Carson. He served as mayor until 2001. Other Filipinos have also been elected to Carson's city council, including Lorelie S. Olaes, Manuel Ontal Jr., and Elito M. Santarina. In Carson as well as in the rest of the South Bay, Filipino Americans serve on various commissions, committees, and neighbor councils as elected and appointed members. Community service organizations empower the community to give back to itself with support to those less fortunate and provide role models for younger generations to come. Shown are some of the many Filipino Americans appointed as commissioners in the city of Carson over the years.

As one of their many duties, Mayor Pete Fajardo and Councilwoman Lorelie Olaes (elected in 1993) represented the city council for many city events, such as Carson's 30th anniversary celebrations in 1998. The city dignitaries are, from left to right, Larry Grant, Gil Smith, Elito Santarina, Bill and Sybil Brown, and Eric Forsberg. (Courtesy of City of Carson, Office of Public Information.)

In 1997, Pete Fajardo became the first Filipino American mayor elected in the City of Carson history. Standing with his wife, Clara, and family, Pete is sworn into public office by Congresswoman Juanita McDonald. Prior to being mayor, Pete was the first Filipino American councilman in 1992. After these elections, other Filipinos followed to run for office and other Filipino-initiated civic organizations were established. (Courtesy of City of Carson, Office of Public Information.)

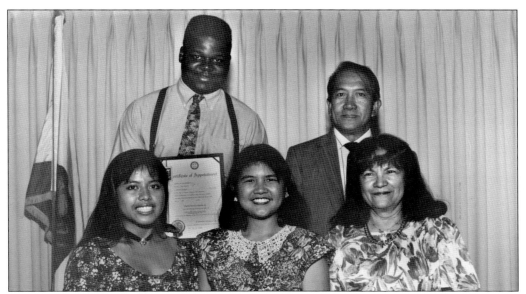

Councilwoman Olaes became the first and the youngest Filipino American councilwoman in the city of Carson in 1993. Her election embodied the aspirations of the Filipino American community to meaningfully participate in the political life of their Carson community and the recognition by other ethnic groups that young people needed a voice in Carson. She is center among her first selected appointees and felt strongly that all committees and commissions should reflect the multicultural nature of the city of Carson (almost equally divided among African Americans, Latinos, Caucasians, and Asian Pacific Islanders). From left to right are (first row) Cheryl Villareal Roberts, Councilwoman Olaes, and Gloria Estrada; (second row) Charles David Livingston and Amador Saenz. (Courtesy of Lorelie Olaes.)

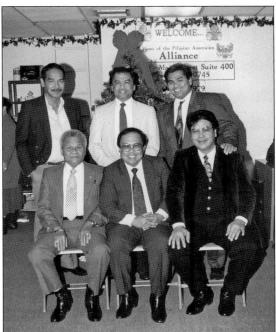

The Pilipino American Alliance (PAA) formed as a political organization to endorse and support Filipino Americans and other candidates who would be a voice for the Filipino American community. Rose Bonoan was the founder and first president, and she currently sits on Carson's 40th Anniversary Steering Committee. In 1993, shown here from left to right, are (first row) Larry Vinluan, Mayor Pro-tem Pete Fajardo, and PAA president Elito Santarina; (second row) Albert Cruz, Emil Loyola, and Jesus "Alex" Cainglet. Elito won his first election as councilman in 2003. (Courtesy of Jun Aglipay.)

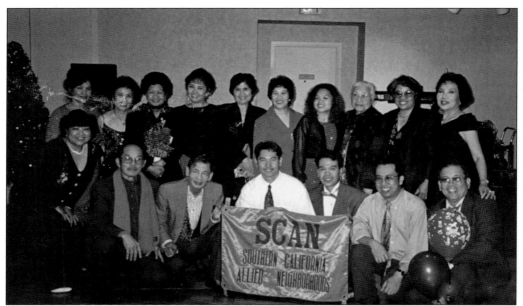

After the campaign work of Councilwoman Olaes, Southern California Allied Neighborhoods (SCAN) continued the work for the expansion of potential Filipino American political candidates and at the same time is a neighborhood-based organization that promoted important issues for the betterment of the community and to reach out to people in need (i.e. food distribution, feeding the homeless, caroling to raise funds). (Courtesy of Perlita Rasing and Murietta Vidal.)

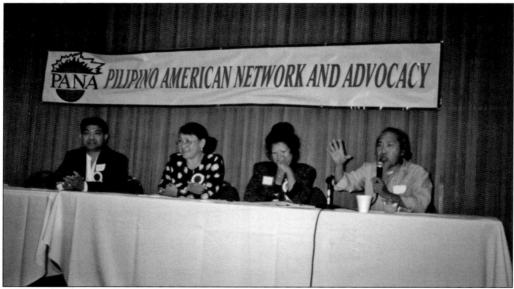

In the early 1990s, the Pilipino American Network and Advocacy (PANA) was established by founding member "Uncle" Royal Morales, shown moderating the panel on the right at the Carson Community Center. His vision was to have PANA become a vehicle for community leaders in various fields, such as community-based organizations, politics, and education to promote collaboration within and to advocate for issues that affect the Filipino American community in Los Angeles County. (Courtesy of Roy Morales Collection.)

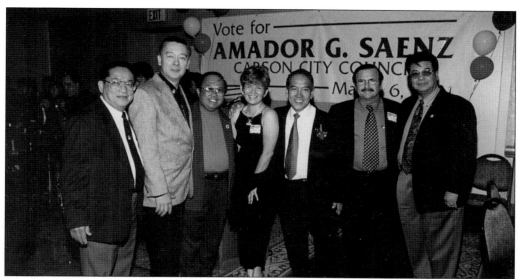

Amador Saenz (current Carson planning commissioner) ran for office in 2001. Among his supporters are, from left to right, Marshall Luna, Henry Ward, Mayor Pete Fajardo, Susan Barlin, Amador Saenz, ? Katz, and Councilman Elito Santarina. Amador Saenz is one of the main founders and first president of SCAN, which included and is a member of the Sun Ray Manor Neighborhood Watch and has an estimated 70 percent Filipino American families living in the area. Sun Ray Manor Neighborhood Watch continues to be one of the city's model community programs. (Courtesy of Amador Saenz.)

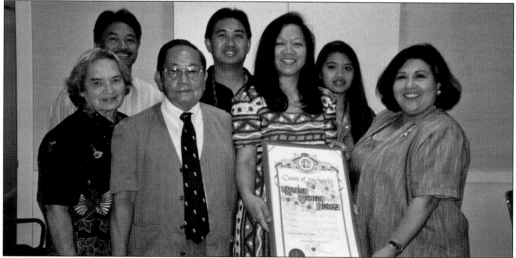

Roselyn Ibanez worked for Los Angeles County supervisor Gloria Molina of the First District from 1986 to 1995. As a senior field deputy, she was able to provide access to Los Angeles City/County services and recommend commission appointees from the Filipino American communities. She currently serves as County Supervisor Molina's appointee on the Community Action Board and served on Carson's Planning Commission as Councilwoman Olaes's appointee in 1998. Roselyn was presented an accommodation by the Supervisor Molina in 1995. Pictured here from left to right are (first row) Helen Brown, Peping Baclig, Roselyn, and Supervisor Molina; (second row) Gil Mangaoang, Florante Ibanez, and Gabriela Ibanez.

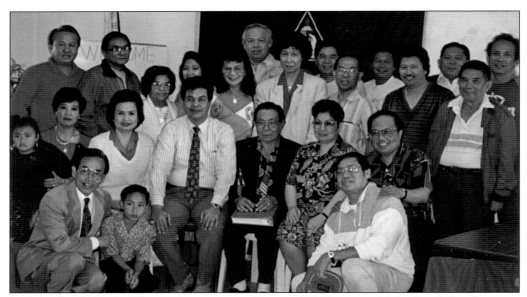

In the early 1980s, the Filipino Community of Carson (FCC) was established and played a major role in the establishment of Carson's First Annual Philippine Independence Day celebration, in which they continue to participate through the years. With a large membership, FCC continues to work on projects, such as the Flores De Mayo celebrations, the rice giveaway program at St. Philomena Catholic Church, and fund-raisers for scholarships to middle school, high school, and college students. (Courtesy of Jun Aglipay.)

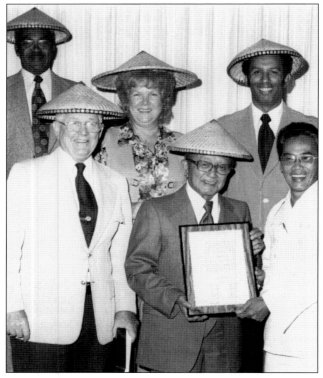

Marcelino Ines Jr. is a well-known and longtime active Carson resident who has been a founder, board member, and president of many community organizations, such as Carson's Sister Cities Association, Kayumanggi Lions Club, and Filipino Veterans Foundation. He serves as an appointee to Carson's 40th Anniversary Steering Committee and Citywide Advisory Commission and was a former parks and recreation commissioner. During Mayor Sak Yamamoto's term of office, Marcelino was presented a certificate of accommodation for service. From left to right are (first row) Councilman John Marbut, Mayor Yamamoto, and Marcelino; (second row) Councilman Clarence Bridgers, Councilwoman Kay Calas, and Councilman Gilbert Smith. (Courtesy of Marcelino Ines Jr. Collection.)

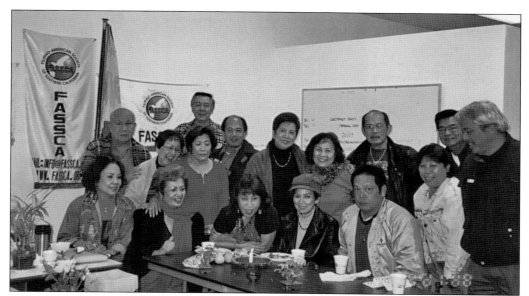

In 2005, the Filipino American Society of Southern California Association (FASSCA) was founded as an organization to serve the community of Carson. The members are, from left to right, (first row) Perlita Rasing, Lilia Tingson, Gilda Dela Cruz, Moy Diamon, Marietta Vidal, George Vidal, Joe Sia, Rudy Cruz, Nanie Martinez, Leoilia Apostol, and Gloria Beers; (second row) Fortunato Tingson, Henry Ward, and current president Dom de la Cruz. (Courtesy of Perlita Rasing and Murietta Vidal.)

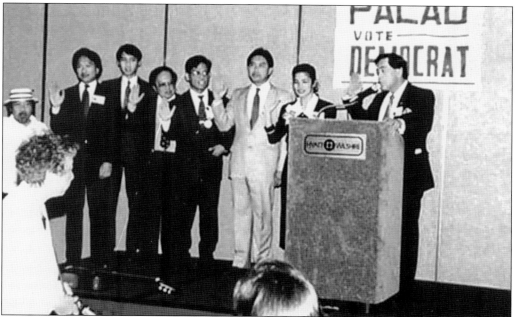

Los Angeles Superior Court judge Mel Recana swears in new officers to the Philippine American Los Angeles Democrats (PALAD). From left to right are Roy Morales, Gil Mangaoang, Michael Balaoing, Pete Fajardo (at that time Carson mayor pro-tem), Gerald Gubatan, Florante Ibanez, and Marissa Castro. Three of the officers resided in the South Bay.

During Mayor Fajardo's first term, the Confederation of Filipino American Associations (CONFAA) was formed by one of the cofounders, Joe Merton, who in turn became the first president. Their projects centered on providing scholarships for Carson High School students, supporting the annual Philippine Independence celebrations, and advocating for the current passage of the Filipino Veterans Equity Bill. (Courtesy of Jun Aglipay.)

While living in Garden, Tony Ricasa, a former UCLA Samahang Pilipino president, has worked for progressive politicians most of his life and used his influence to advocate for Filipino American issues and concerns. As an alumnus, he is being honored by the organization for his service to the community in 1997.

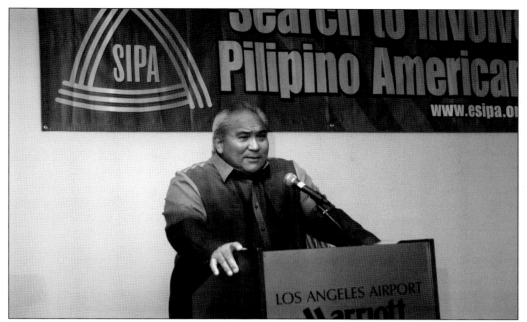

Filipino Americans have been appointed commissioners throughout the South Bay whether it is for a local municipality, Los Angeles County, or the state of California. Shown here is Benito Miranda, appointed as Torrance's first ever Filipino American cultural arts commissioner in 2006. He was also on the board of SIPA and the Federation of Fil-Am Associations of Long Beach.

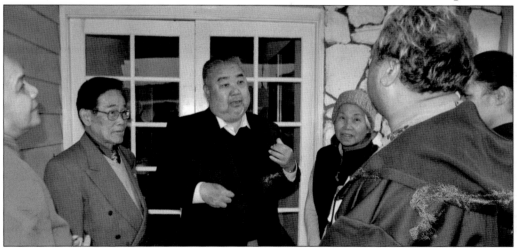

In 2008, assembly member Warren Furutani was first elected for the 55th Assembly District. The district encompasses the cities of Carson, Lakewood, parts of Long Beach, and a portion of Los Angeles (Harbor City, Harbor Gateway, and Wilmington). These communities have a large concentration of Filipino Americans. Pictured here is an election campaign brochure Warren developed specifically to reach out to the Filipino American community. During his first term, Furutani passed Assembly Joint Resolution (AJR) 65, Preservation of Filipinos/Filipino American Communities. AJR 65 recognizes the history and cultural heritage and the role the community played in the development of California and will pursue preservation. (Courtesy of Warren Furutani.)

With a large concentration of Filipino Americans living in the city of Carson, it has been undoubtedly one of the first U.S. communities to have a Filipino American mayor, councilmen, and councilwoman to hold office and thus had numerous Filipino Americans appointed to key commissions. When Hawaiian governor Ben Cayetano visited and was honored at the Carson Community Center, he was also presented a gift from the Asian Pacific American Law Students of Loyola Law School, his alma mater. They asked Florante Ibanez, who worked at the law school, to present it for them. Cayetano also attended Harbor Junior College and UCLA.

As more Filipino American leaders become part of the support base of many Carson elected officials throughout the years, the Filipino American community continues to recognize the significance of participating in local government and attending the various meetings at the Carson City Hall. (Courtesy of Perlita Rasing and Murietta Vidal.)

Seven

SULONG MEANS MOVING FORWARD

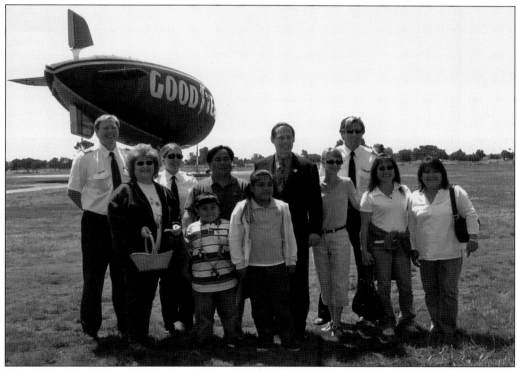

The motto for the city of Carson is "Future Unlimited," and it applies to its Filipino American community as well. Hospitality, sharing, and hard work are all positive Filipino traits. While the previous chapters attempt to capture the history and cultural story of Filipinos in Carson and the South Bay, the future belongs to the young Filipino American families and youth still preparing to make their mark on society. To our future professionals, politicians, cultural artists, and community organizers, the authors provide this documentary book as archival proof that Filipinos have moved forward with deep historical roots and valuable cultural values all Americans can be proud of. In 2003, these elementary and middle school students above won the privilege to ride in the Goodyear Blimp with Mayor Jim Dear for winning the Carson City Essay Contest on "Why I like Carson."

ABC news personality Denise Dador (center back) congratulates these San Pedro Girl Scouts of Troop 1080 for their community service. In the second row at right is their troop leader, Gwen Abrenica Rohar. The event was a San Pedro fund-raiser for the Hope for Kids organization in 2001 by Dr. Francine Inez-Johnson.

These Knights of Columbus stand in front of St. Philomena Catholic Church in their full regalia and offer their service to the church. Third from the left is Jesus Guerrero, who has a long history of Carson and Wilmington Filipino community involvement. Founded in 1882, the Knights are dedicated to "Charity, Unity, Fraternity, and Patriotism." (Courtesy of Guerrero family.)

Local youth have also been eager to organize on their high school campuses. Pagkakaisa at Narbonne High was started by Gabriela Ibanez in 1994. Like other students, she decided it was an important step for students to come together, learn about their identity, and share their culture and history with others. In the past, UCLA students conducted "sala or garage talks" to get in touch with high school students about their culture and also promote a link to their university as a recruitment tool. Here the Carson High youth participate in the June 12 Philippine Independence Celebration at Veterans Park in 2008. Filipino clubs can also be found at Banning Jordan and Poly high schools.

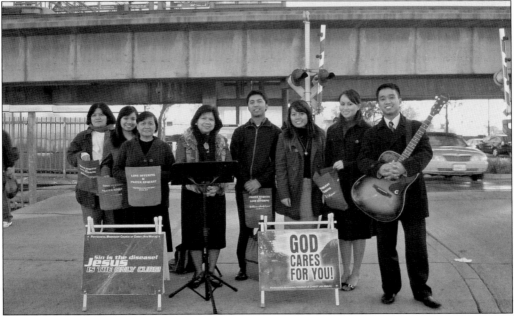

In another form of recruitment, at the Santa Fe Avenue and Del Amo Boulevard MTA Blueline train station, members of Pentecostal Missionary Church of Christ–South Bay can been seen singing, preaching, and engaging people to attend church, read the Bible, or make a donation.

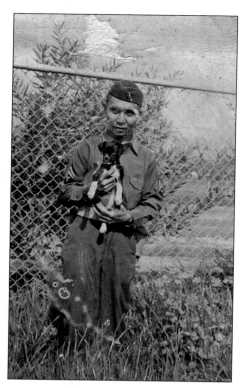

Marie Jo SaHagun-Taitague is proud to be part of an army family of four generations. In the photograph above is her father, Ponce SaHagun, who served in World War II as an army sergeant in the Medical Corps. Below is her son Jayson Taitague who was commissioned as 2nd lieutenant while in the ROTC of the New Mexico Military Institute. Julio SaHagun, her grandfather, was recruited while in the United States to join the Philippine Scouts and return to the Philippines in the early 20th century. He served for 12 years before coming back to America with his 10-year-old son, Ponce. Marie Jo grew up in Torrance and attended Narbonne High and was one of the founding members of the Pilipino American Coalition (PAC) at Cal State University–Long Beach. After college, she joined the army in 1976 and toured at many posts including Hawaii, Korea, and Walter Reed as a staff sergeant until 1999. She married Benny Taitague, who joined the air force during the Vietnam War. (Both courtesy of Marie Jo SaHagun-Taitague.)

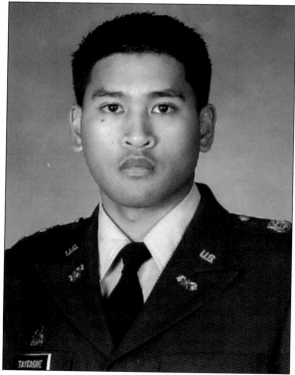

Maj. Valvincent Reyes was deployed to Afghanistan in 2002 as an army reservist who was a Los Angeles County probation officer who grew up and still lives in Torrance. He felt proud of his role in the war effort—screening soldiers for combat-related stress disorders. His concerns and comments as well as his picture were captured in an *LA Times* article dated September 18, 2002. Today Reyes teaches at USC. While in Afghanistan, he had the opportunity to meet Drew Carey, who was there to entertain the troops. (Courtesy of Valvincent Reyes.)

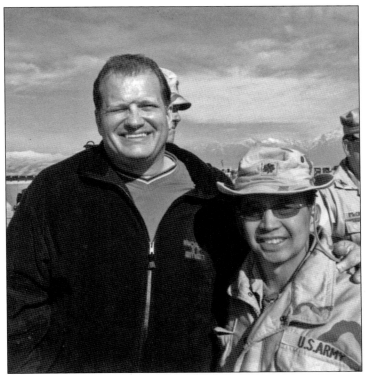

The famous Pulitzer Prize–winning photograph of the "Marlboro Marine," Lance Cpl. James Blake Miller, was shot by Filipino American and Long Beach resident Luis Sinco (left) for the *Los Angeles Times* in Fallouja back in 2004. Sinco did a follow-up set of *LA Times* articles in 2007 about how both their lives had changed and yet became intertwined because of that photograph. Here he is with Miller (right) in the aftermath of all the publicity. (Courtesy of Luis Sinco.)

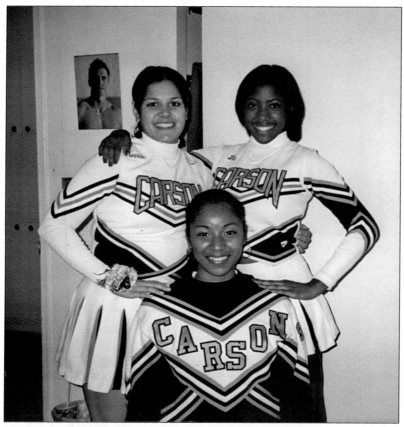

These three Carson High School cheerleaders from 1998 are, from left to right, Marcie De La Cruz, MaKatrina Myles, and Tia Gainous. The Carson High flag girls (below), marching band, and drum line have a history of competing and winning. The photograph below was taken at a drum line completion in 1992, and some of its notable members were Minda Sanchez, Icy Ice, and Alison De La Cruz. (Both courtesy of Alison De La Cruz.)

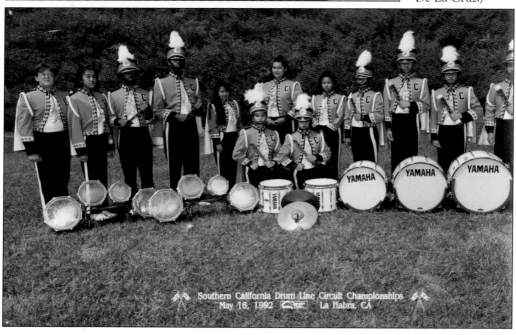

Southern California Drum Line Circuit Championships
May 16, 1992 La Habra, CA

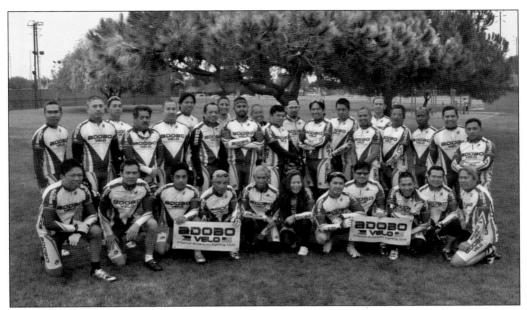

ADOBOVelo had its cycling roots before it got its name in 2005. As "SoCal's fastest-growing and the biggest Fil-Am Cycling Club," they have about 100 riders of various levels and they have organized club rides all the time. Viewers can catch them on Tuesday and Thursday evenings around 6:30 p.m. during their regular Carson Criterium near Santa Fe Avenue and Carson Street or on their Web site.

Tony dela Cruz (front row, far right) was a star basketball player at Carson High and for UC Irvine's Anteaters. He was signed up in 1999 directly from UC Irvine to play in the Philippine Basketball Association's Shell Turbochargers as a professional. In 2005, he joined the Alaska Aces and was picked for the national Olympic team. (Courtesy of Alison De La Cruz.)

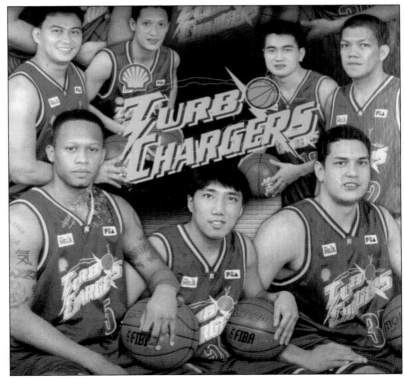

The four original 1971 cofounders of the UCLA Samahang Pilipino student organization are pictured in a rare gathering during the 2005 UCLA Samahang Pilipino Cultural Night (SPCN) at Royce Hall. Three out of the four grew up in Wilmington and Carson. They are, from left to right, Florante Ibanez, Sheila Tabag-Napala, Jennifer Masculino Tolentino, and Judge Casmiro Tolentino.

Pictured are members of the University of California Irvine Kababayan Alumni Chapter (KAC) during their 2004 gala celebrating the 30th anniversary and reunion of Kababayan at UC Irvine. Most of the founding group of Kababayan in 1974 came from the South Bay. Since then, there has been a steady flow of Filipino American student recruitment from the area to the campus.

One of the first cochairwomen of Kababayan at UC Irvine was Roselyn Ibanez. Here she helps a graduating senior with her Filipinana stole during the UC Irvine Pilipino graduation ceremonies, also known as P-Grad, in 2001.

Filipinos have a long history with International Longshore and Warehouse Union (ILWU) in the Long Beach and Los Angeles port complex. Even the Terminal Island cannery workers were covered by their contracts. Here are union members, from left to right, Laurene Rossi Hallman, Steven Allard, Virgie Rossi, and Irma Rossi calling for support for their labor contract.

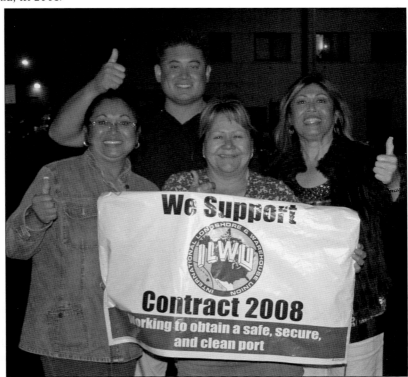

For the struggle to gain World War II Filipino Veterans Equity, Eric Lechica came from Washington, D.C., to address Long Beach and other South Bay community leaders in 2007. The meeting took place in the Lafayette Hotel, which had a history as a popular venue for Filipino dances in the 1950s and 1960s. The hotel was one of the first to go into condominium conversion in 1968.

During the 1998 Festival of Philippine Arts and Culture (FPAC) held at Cabrillo Beach, San Pedro, the Friendship Club, made up of the Filipino Lions Clubs of District 4-L3, came together to host their mobile health-screening unit (MSU) with free eye-sight examinations, hearing tests, and blood-pressure readings.

The Filipino American Library conducted various children's reading programs in collaboration with public libraries, using Filipino children's books and arts and crafts and involving parents. One of these sessions was held at the Carson Public Library. At the time, there were three Filipina librarians on staff. Leticia Tan is the current branch manager.

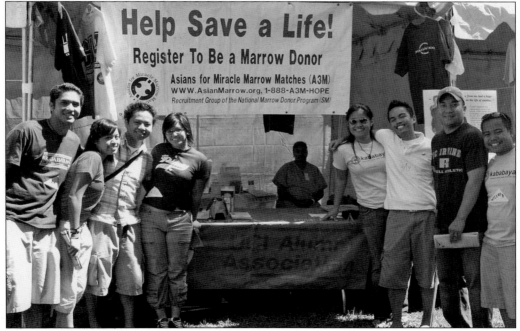

Here UC Irvine students and alumni assist during a bone marrow registration drive at the Festival of Philippine Arts and Culture in San Pedro. The drive was held by Asians for Miracle Marrow Matches (A3M), which has a specific Pilipino Task Force for community recruitment.

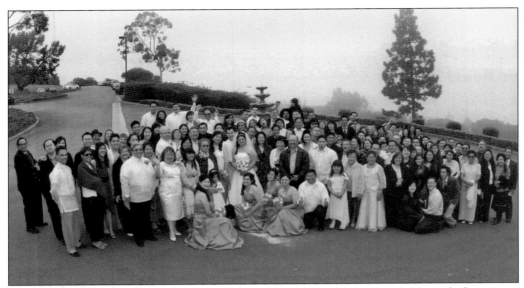

Mixed marriages are nothing new to the Filipino American community and there is far less stigma attached today than in the early days of immigration and anti-miscegenation laws. Gabriela Ibanez wed Hoan Vinh Nguyenphuoc (center) and became Gabriela Nguyenphuoc in 2008, and the Vietnamese and Filipino cultures became mixed. (Courtesy of Nguyenbphuoc family.)

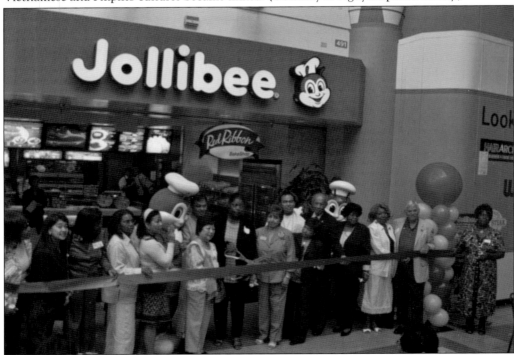

Jollibee is considered to be the McDonald's of the Philippines, and now Carson has two of them. Cheryl Roberts (fifth from the left), a manager for the South Bay Pavilion, is on hand, as was Mayor Jim Dear and other public officials, for the official mall ribbon-cutting ceremony. (Courtesy of Cheryl Roberts.)

A vegetarian Filipino restaurant is unheard of unless one goes to El Segundo's Papillon. Owner Chris Florido started his family business originally to satisfy his own yoga master vegetarian needs, but it soon took off with rave reviews. They also serve Filipino dishes with meat, and many times, customers will try both versions of a particular dish to see if they can tell a difference. Florido also has hosted special community events in his restaurant and works with local Filipino college groups for catering.

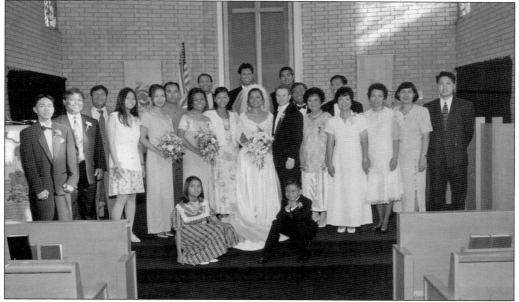

The last wedding to take place at the Long Beach Naval Station Chapel was held for Darrell and Julie Hatch (center) on July 6, 1996. This base, as with other military installations, was being closed down during this period. Still the Hatch wedding was a joyous event. (Courtesy of Hatch family.)

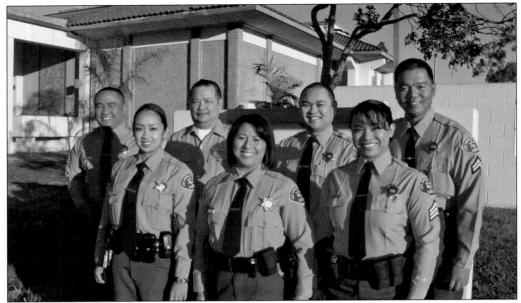

The Carson Sheriff station today has many Filipino Americans working its various shifts with different responsibilities. These officers were able to come together for this rare picture opportunity. They are, from left to right, (first row) Deputy Christina A. Banogon, Deputy Lara A. Damolie, and Sgt. Faye A. Bugarin; (second row) Sgt. Roy S. Pascual, law enforcement technician Carlito S. Panlilio, Deputy Danilo R. Castaneda Jr., and, Deputy Froilan A. Dinco.

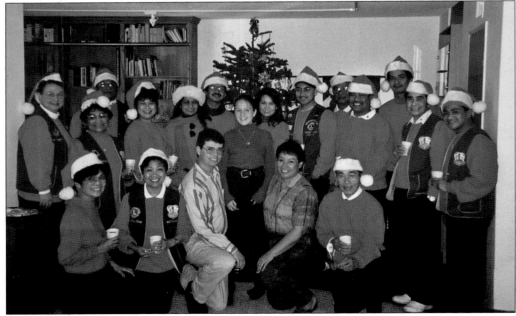

"We Serve" is the motto of Lions Clubs International. The Kayumanggi Lions Club has been serving the South Bay communities since 1979 as the first Filipino American Lions club in their District 4-L3. During their Christmas caroling fund-raising, the club was treated to snacks and hospitality from the Baker family in Rancho Palos Verdes.

Winston Emano (center) and good friends Maria Quiban, Fox 11 News weather anchor (left), and Brook Lee, Miss Universe 1995 (right), pose for posterity during the Filipino American Library 2005 gala. Winston and his family have strong South Bay roots. As children, they attended St. Philomena School, and Emano played on the Bishop Montgomery High football team. He also attended El Camino College. Today Emano serves on the board of FilAm ARTS and helps produce the Festival of Philippine Arts and Culture. (Courtesy of Ned Vizmanos.)

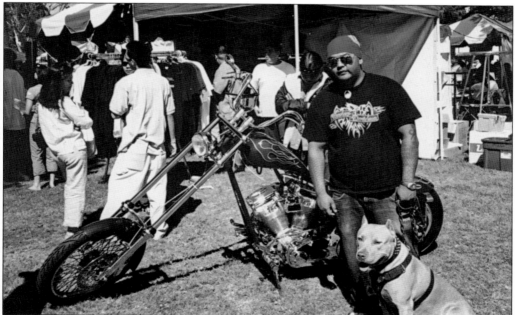

Edwin Habacon is an up-and-coming actor from Carson. He has worked on *Pirates of the Caribbean: At World's End*. Previously he owned and operated the Tribal Pinoy clothing business. Here he is with his custom chopper at the Festival of Philippine Arts and Culture in front of his Tribal Pinoy booth. Edwin has also worked at SIPA and is still a community activist.

Sarah Reyes (second from left) and Mikaela Ibanez (second from right) have been best friends and were selected to participate in the Academy of Business Leadership (ABL) 2005 Summer Business Institute at Cal State University Dominguez Hills. With their program, they were able to meet and learn from industry leaders. Here they are during the ABL graduation ceremony.

Mrs. and Mr. Walter Dagampat celebrated their 50th wedding anniversary at the Sequoia Complex in Buena Park on November 30, 1991. They were surrounded by children, grandchildren, and great-grandchildren. The Dagampat family has deep roots and history in the South Bay. Multiple generations will carry on their legacy. (Courtesy of Al Bitonio.)

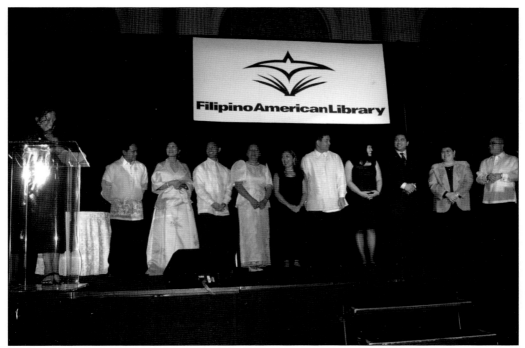

The mission of the Filipino American Heritage Institute/Filipino American Library is to actively promote the history, culture, and professional achievements of Filipino Americans through educational and cultural programming, thereby contributing to the development of a culturally dynamic, multiethnic America. (Courtesy of FilipinoAmericanLibrary.org.)

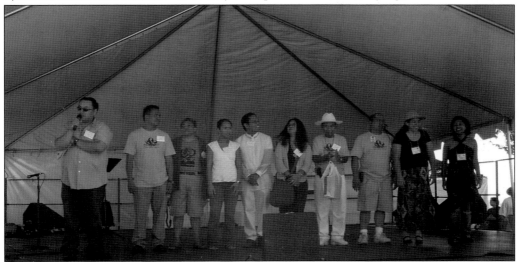

The Association for the Advancement of Filipino American Arts and Culture (FilAm ARTS) is a multidisciplinary community arts organization whose mission is to advance the understanding of the arts and diverse cultural heritage of Filipinos in the United States through presentation, education, and arts services. FilAm ARTS provides arts as a service to the community through three major programs: Festival of Philippines Arts and Culture, Pilipino Artist Network, and Eskuwela Kultura. (Courtesy of FilAmARTS.org.)

ACROSS AMERICA, PEOPLE ARE DISCOVERING
SOMETHING WONDERFUL. *THEIR HERITAGE.*

Arcadia Publishing is the leading local history publisher in the United States. With more than 5,000 titles in print and hundreds of new titles released every year, Arcadia has extensive specialized experience chronicling the history of communities and celebrating America's hidden stories, bringing to life the people, places, and events from the past. To discover the history of other communities across the nation, please visit:

www.arcadiapublishing.com

Customized search tools allow you to find regional history books about the town where you grew up, the cities where your friends and family live, the town where your parents met, or even that retirement spot you've been dreaming about.